CANDLESTICK PARK

CANDLESTICK PARK

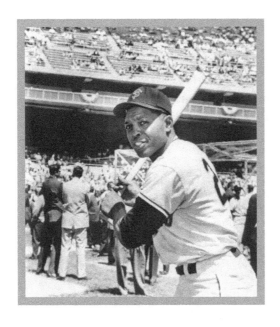

Ted Atlas
Foreword by Mark Purdy

ARCADIA
PUBLISHING

To my family, Leta, Greg, and Beth, and to my parents, Charles and June Atlas, who took me to Candlestick Park for the first time.

Copyright © 2010 by Ted Atlas
ISBN 978-1-5316-5404-7

Published by Arcadia Publishing
Charleston, South Carolina

Library of Congress Control Number: 2010928646

For all general information, please contact Arcadia Publishing:
Telephone 843-853-2070
Fax 843-853-0044
E-mail sales@arcadiapublishing.com
For customer service and orders:
Toll-Free 1-888-313-2665

Visit us on the Internet at www.arcadiapublishing.com

CONTENTS

ACKNOWLEDGMENTS

They say no one person can make a pencil. I have learned the same is true of writing a book. I have many to thank, starting with John Garvey for his knowledge and contact information. Thank you to Mark Purdy for a great foreword. I could not have collected enough materials without Rick Swig, the ultimate collector of all things Giants. Also at the top of my list is Heather Hollingworth, who edited my text, and Jane Bolles Grimm, who shared pictures and stories of her father.

In the baseball subject matter, I am grateful to Jaime and Kim Rupert, Lon Lewis, Charlie Hallstrom, Hank Greenwald, Sherry Davis, Andrew Holloway, Kerry Yo Nakagawa, Mitsuhiro Murooka, and Russ Moshier. Thank you to Pat Gallagher for his knowledge of the stadium and the Giants' marketing efforts and to Giants president Larry Baer for sharing his experiences. Thank you to Dave Cross for his great photograph of October 17, 1989.

I could not have done this book without the assistance of Jim Mercurio, vice president of Stadium Operations for the 49ers. I am also grateful to president Jed York and his staff in Santa Clara who allowed me access to their photograph archives. Also thanks to Dan Henderson and Bob Mallamo at the 49ers. I am grateful to Bill Fox and Dennis Desprois for allowing me to use their photographs. My thanks to Mo Fowell and Jim Wyatt for their help.

Thank you to Michael Olmstead and Erin Olmstead at e2k Events for allowing me access to their files. Thank you, also, to stadium manager Mike Gay for his photographs and knowledge.

Thank you to the following for the concert and other materials: Joel Selvin, Ken Friedman, Len Hruszowy, Shayla Moore at Gordon Biersch, Tony Ferrari, Dennis Mattish, Gary Horstkorta, Nora Hannah at Until There is a Cure, Jeff Hoganson, and Barry Hood.

Thank you, also, to Max Schultz, Heather David, Christina Moretta, Jeff Thomas at the San Francisco History Room, and Joe Ferreira.

Thank you to my editor John Poultney, and thank you to Apple, as I processed hundreds of photographs without a computer crash.

FOREWORD

I am a lucky guy. As a newspaper sports columnist for more than 30 years, I have covered Olympic Games on four different continents and American sports events in all four time zones.

As such, I have passed through many stadium gates. I have eaten much bad concession stand food. I have viewed great and boring games, in wonderful and wretched weather, from good and awful seats.

Occasionally, someone asks: "Which stadium or ballpark is your favorite?" I never blink.

"That's an easy one," I say. "Candlestick Park."

Whereupon I am usually met with a reaction that incorporates horror, amusement, bafflement, and the same facial expression worn by that kid in the film *Home Alone* when he discovered his family had abandoned him.

I understand. If there is a sports venue anywhere that has a worse reputation than Candlestick in terms of fan comfort and lousy climate conditions, I can't think of one. Unless you count a gravel pit somewhere in Saskatchewan for an outdoor January hockey game.

But my favoritism for Candlestick will never waver. I adopted the stance late in the afternoon of Oct. 17, 1989. And I have rejected any and all arguments to un-adopt it.

That afternoon, I stood in the upper deck auxiliary press area behind home plate as the largest earthquake of my lifetime hit the Bay Area.

And the place held together. Despite all those people, waiting to watch a World Series. Despite a capacity crowd, putting all that weight on all those girders and all that cement. Despite shaking so violent, a worker on a light tower was holding on for dear life.

From that moment until the end of time, I promised myself, I would always consider Candlestick my favorite sports venue anywhere.

There are other reasons to be fond of the dank old joint. But the ability to survive a major quake that was strong enough to collapse a freeway in Oakland will always rank at the top. Candlestick has never been a romantic structure. It has definitely been a compelling and unforgettable landmark. It has seen legendary games and provided a stage for players to become immortal. For sure, Candlestick deserves its own historic tribute book.

Ted Atlas is the perfect person to assemble one. He has been a security guru at sports venues across America for nearly as long as I have been haunting them. He has probably walked the concourses and hallways beneath Candlestick as often as any other human being. He has dealt with the athletes, the general admission folks, the college kids, the families, the ushers, the luxury box swells, the custodians, the celebrities and the drunks. Ted can tell you all about The Stick's nooks and crannies. He knows the stadium's various neighborhoods. He has experienced the park's multiple personalities.

It sounds funny that a stadium would have different neighborhoods. But that's what they are. One Candlestick neighborhood would include the upper deck seats, which were always filled after

the 49ers began winning in 1981. But during the many sparsely attended baseball games on cold nights at "The Stick," college couples would sit up there in the top rows and get to first base. Or second base. Or further. If you know what I mean.

There was also the Stadium Club neighborhood, where the swells would hang out before and after games and you might spot a celebrity. And the Beyond Centerfield neighborhood, way out there in the boonies and in the parking lots facing the bay, where tailgate parties would percolate. And the Narrow Concourse with Garlic Fries Odor neighborhood, which is self-explanatory.

Of course, I have my own favorite Candlestick neighborhood—located underneath the seats. I remember the funky old 49ers locker room, which had two levels. Quarterbacks and offensive players dressed upstairs; defenders dressed downstairs. I spent a lot of time at the first locker on the right at the top of the stairs, occupied by Joe Montana and later, Steve Young.

I also recall the old Giants locker room, which has since been remodeled into the new 49ers locker room. Willie Mays and Willie McCovey would pad across the damp floor before and after games. In the 1980s, outfielder Candy Maldonado angrily backed me across the room when he didn't like something I'd written about him. I was concerned he might actually punch me until the door to Roger Craig's office opened behind me and he jumped in to mediate the dispute.

But my favorite room might be the visiting locker room that's used for both baseball and football. This is also the room where the Beatles and Rolling Stones, among others, tuned up for their concerts at The Stick. I always thought it was amusing that John Lennon, Tommy Lasorda, Mick Jagger, Willie Nelson, and Mike Ditka had all occupied the same small space over the years. If the walls of that room could talk, do you think they could even explain what that was like? (The Grateful Dead also sang the national anthem before one opening day. I asked Jerry Garcia if he had played Little League baseball. He said that he'd been a softball pitcher but never played much hardball. Somehow, that made sense.)

As for Candlestick's multiple personalities . . . well, ask any baseball fan who ever showed up there for a 1 o'clock game in sunny, 68-degree calm conditions and stayed through extra innings until 5 o'clock or so, when the temperature dropped 15 degrees and frigid wind began whipping hot dog wrappers around the outfield. Football can also be a wild card. December can mean a sublime blue-sky experience, a swirling breezy adventure, or a driving El Niño rainstorm. Field goal kickers have had nervous breakdowns trying to figure out the devilish wind.

My personal favorite Candlestick personality is the Frankenstein's lab impersonation, which surfaces on nights when the fog rolls in and covers the light poles with a wisp's white curtain in the damp chill. I keep waiting for Freddy Krueger to emerge from the shadows. For visiting football teams, I think that's worth at least a touchdown disadvantage.

Candlestick's atmospheric conditions are caused by some unique geography and science. The stadium sits directly east of the San Bruno Gap, the only opening in the coastal hills between the Golden Gate and Half Moon Bay. That means when the summer sun bakes the Central Valley of California and causes the hot surface air to rise in Modesto or Turlock, that hot air is replaced by cold air over the ocean a hundred miles away—and most of that cold air is sucked through the San Bruno Gap. Because the opening is so narrow, it multiplies the velocity of the cold air as it blows right across Daly City and directly across Candlestick Point before dispersing as it crosses the bay. The effect is called Bernoulli's principle.

Obviously when planning the stadium, nobody ever consulted Bernoulli or his principal.

The story goes that in 1957 when New York Giants owner Horace Stoneham was pondering a move west, San Francisco boosters took him to visit the Candlestick site after breakfast when the air was calm. He eagerly signed the deal, only to make an ominous visit after construction was underway.

"Does the wind often blow like this?" Stoneham supposedly asked a worker.

"Yeah, every day," the worker replied. "But only in the afternoon and early evening."

Apocryphal or not, I love that image. And however it happened, I am glad Stoneham followed through on his decision to move West. If he had not, think how much excitement Bay Area sports fans would have missed—both from the Giants starting in 1960 and later from the 49ers, who moved into the place following a major remodeling job in 1971.

The great thing about a book like this one is that with the proper photograph selections, the pages can take you right inside all of these neighborhoods, nooks, and rooms I have mentioned. If you've ever been to The Stick, it will bring back memories. If you haven't, it will make you jealous. Atlas has done yeoman's work tracking down some of the coolest Candlestick pictures you've ever seen—and many you haven't. He has even located a rare picture of an Oakland Raiders' home game played there. Did you know that the Raiders actually used The Stick as a home field before the 49ers did? You do now.

Savor every picture. Soak up every caption. But before you continue and turn the page, I suggest that in order to capture the total Candlestick appearance, you go sit in front of your refrigerator door with a portable fan blowing in your face, with a steamed hot dog in your mitts, and the sound system playing a Huey Lewis and the News song.

There. You are all set for the Ted Atlas tour of America's quirkiest, enthralling, and hilariously cursed sports venue. Enjoy at your own risk. I'm guessing you will.

—Mark Purdy
San Jose Mercury News

CANDLESTICK POINT

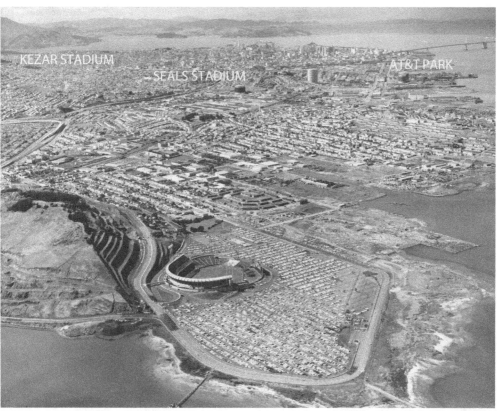

Candlestick Park is located at Candlestick Point in the southwest corner of San Francisco. It is on the edge of the Bayview-Hunters Point neighborhood. Kezar Stadium was in Golden Gate Park adjacent to the Haight-Ashbury. Opened in 1925, it was the home field for the popular college teams of Santa Clara University, St. Mary's College, and the University of San Francisco. The 49ers played there from 1946 to 1970, and the Raiders played five games there in 1960. Seals Stadium was at Sixteenth and Bryant Streets in the Mission District. Built in 1931, it was home to the Seals and the San Francisco Missions of the Pacific Coast League. The Giants played there in 1958 and 1959 while Candlestick Park was being built. Opened in 2000, AT&T Park is located at Third and King Streets in China Basin. The stadium, built and operated by the Giants, is considered one of the finest in Major League Baseball. This general location was among those considered before Candlestick Point but was rejected as it was too close to port operations and industrial plants. (Courtesy Jane Bolles Grimm.)

Drawings showed the need for transportation and infrastructure. A crossing to link the southern part of the city to the East Bay had been discussed since 1948, and the California Department of Highways had a plan for a crossing at Army Street (now Cesar Chavez Street). But in 1959, Resolution 45–59, which opposed many planned freeway routes, was passed. (Courtesy San Francisco History Center, San Francisco Public Library.)

Government officials and newspaper writers proposed elaborate plans for development around Candlestick Park. Among those ideas was to host a World's Fair on more filled-in bay lands south of the stadium. San Francisco had previously hosted a successful World's Fair in 1939 and 1940 on Treasure Island, but plans for one near Candlestick Park never materialized. (Courtesy San Francisco History Center, San Francisco Public Library.)

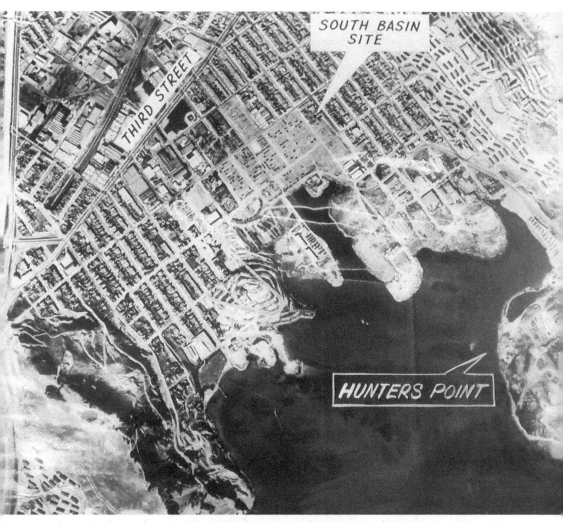

A second site for the stadium was considered in an area between Candlestick Point (lower left corner) and Hunters Point Naval Shipyard. During the grand jury investigation in 1958 nobody could testify as to who actually picked Candlestick Point as the site for the stadium. It is, however, believed to have been Mayor George Christopher. *California Geographic Names* lists Candlestick Point as being named for a pinnacle of rock noted in a U.S. National Geodetic Survey in 1869, "SE from and under Visitacion Knob, about 130 feet above the high water mark and directly over 8-foot sharp pinnacle of rock near high water mark." Jose Canizares, a pilot in the De Anza Expedition in 1781, also noted the rock. Located near the east side of the stadium, the rock formation appeared on survey charts through 1920 but then disappeared. Others attribute the name to a long-billed curlew bird named the "candlestick bird" that was indigenous to the area, but whose population declined in the area in the early 20th century. (Courtesy San Francisco History Center, San Francisco Public Library.)

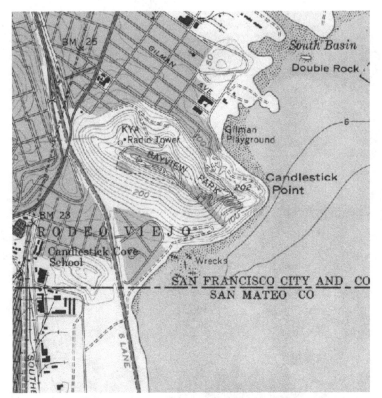

Candlestick Point remained untouched in 1956. The KYA radio tower on the north side of Visitacion Knob was on land owned by the Hearst Corporation. The south side land was part of 3,000 acres owned by Charles Crocker (one of the Big Four of the Central Pacific Railroad) that he donated to the city in 1915 as a park to prevent a planned quarantine facility. (Courtesy author's collection.)

Candlestick Point was cut down in order to build the stadium and Jamestown Avenue. The rocks and dirt were used to fill in the tidelands for the parking lots and what would become Candlestick Point State Park. Charles Harney did not have to pay for the fill material, which was part of the controversy surrounding the sale of the land for the stadium. The map is from 1968. (Courtesy author's collection.)

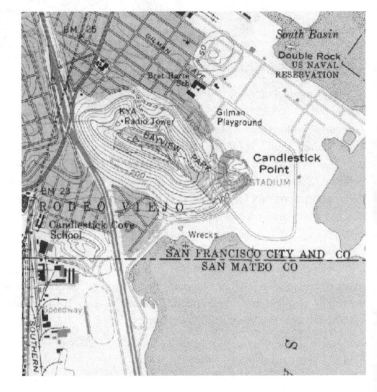

Horace C Stoneham (signature)

HORACE C. STONEHAM

PRESIDENT
SAN FRANCISCO GIANTS

CANDLESTICK PARK
(415) 467-8000

Horace Stoneham became the youngest owner in baseball at age 33 when his father, Charles, died in 1936. He was one of the last owners who had no other businesses than the team. As an innovator he was one of the first to sign players from the Caribbean, the first to explore moving his team to the West, and the first to sign a player from Japan. He is often negatively compared to Dodgers owner Walter O'Malley and merely followed O'Malley to California. In fact, he decided two months before O'Malley to move to California. In what may have been his most important decision, he signed Willie Mays, arguably the best player ever in the game, to a contract when O'Malley passed on him fearing that having more than a few black players on his team would turn off fans. (Courtesy Rick Swig.)

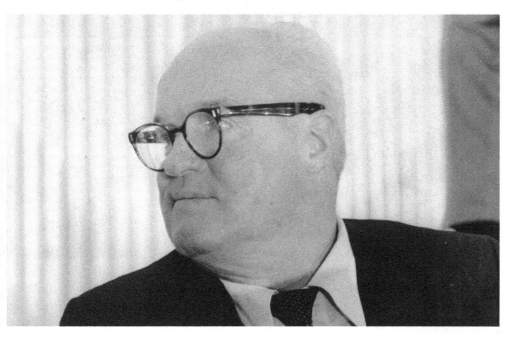

In addition to the New York Giants, Charles Stoneham owned the California Copper Consolidated mine in Copperopolis in the foothills of the Sierra Nevada. In the early 1920s, Horace Stoneham spent a year working in the mine after dropping out of Fordham University. He then returned to New York where he worked in the Giants ticket office and learned about the administration of the team. (Courtesy Calaveras County Historical Society.)

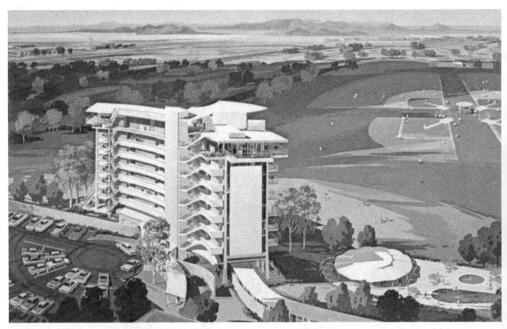

Francisco Grande was developed in 1958 by Horace Stoneham as one of the first golf destination resorts in Arizona. Located halfway between Phoenix and Tucson, it was popular with celebrities such as John Wayne. In 1947, Stoneham along with Cleveland's Bill Veeck, were the first owners to locate spring training camps in Arizona. (Courtesy Rick Swig.)

Founder Anthony "Tony" Morabito, his brother Victor, and two partners formed the 49ers in 1946 with many local college players. After being rejected by the National Football League, the 49ers joined the All-American Football Conference. Then in 1949, the 49ers, the Browns, and the Colts moved to the National Football League when it merged with the All-American Football Conference. The remaining teams disbanded, and the players were reallocated. (Courtesy the San Francisco 49ers.)

A bench at Candlestick Park honors the memory of 49ers founder Anthony Morabito who saw the potential of professional football after World War II, even though football would continue to lag behind baseball's popularity for many years. At the age of 47, Morabito suffered a fatal heart attack during a game against the Chicago Bears at Kezar Stadium in 1957. Morabito had also owned a lumber company in San Francisco. (Courtesy author's collection.)

As the New York Giants and the Philadelphia Eagles competed, representatives of the NFL and the All-American Conference met, having been summoned to New York by Horace Stoneham. As the owner of the Polo Grounds, Stoneham was landlord to two NFL teams and knew both leagues were losing money. Four days later, they agreed to a merger, saving three AAC teams, including the 49ers. (Courtesy Steenosports Memorabilia.)

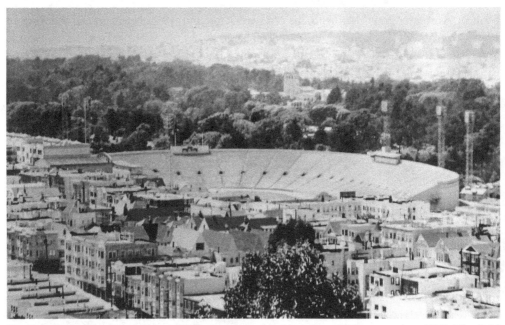

Kezar Stadium, located in the southeast corner of Golden Gate Park, opened in 1925. The field was positioned toward the sun because John McLaren, the park superintendent, did not want to reduce his rhododendron grove. The San Francisco 49ers started playing there in 1946, and the Oakland Raiders played five games there before moving to Candlestick Park. (Courtesy San Francisco History Center, San Francisco Public Library.)

Wide receiver R. C. Owens caught a pass in a game on August 16, 1959, at Kezar Stadium against the Washington Redskins. Owens was famous for catching the "Alley Oop" pass thrown by quarterback Y. A. Tittle. This high-arcing pass, which relied upon Owens's jumping ability, was the predecessor to the modern "Hail Mary" play. (Courtesy San Francisco 49ers.)

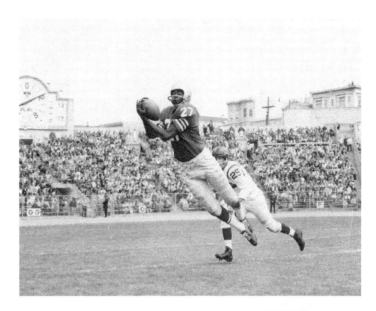

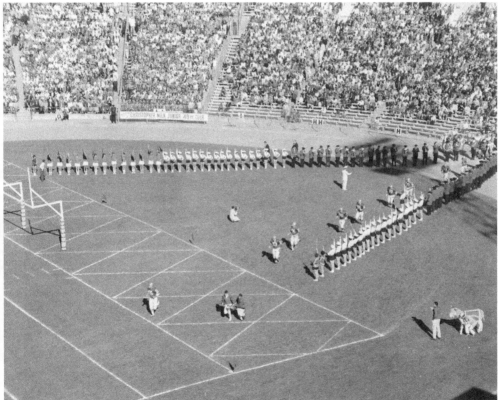

The 49ers players are shown being introduced before a game at Kezar Stadium. The team was not always able to sell out the 60,000-seat stadium, which was replaced with a much smaller 9,000-seat stadium in 1990. The donkey in the lower right corner was known as Clementine and was the first mascot for the team. (Courtesy Michael Olmstead-e2k Events.)

In 1957, there were 11,606 fans watching as Don Mueller scored the last run for the Giants at the Polo Grounds by besting Pirates catcher Hardy Peterson to score on a sacrifice fly by Dusty Rhodes. The Giants lost 9-1. In 1962, they returned to the Polo Grounds to face the New York Mets before the Mets moved to Shea Stadium, a location once considered by the Giants. (Courtesy Rick Swig.)

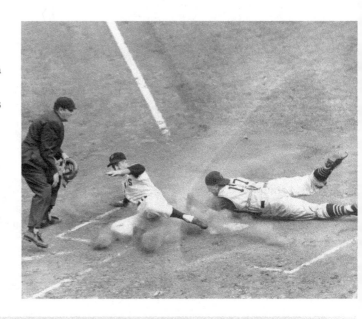

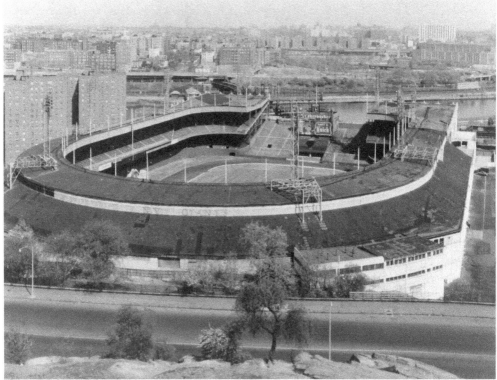

The Polo Grounds, sometimes referred to as "Coogan's Bluff," as the Coogan family owned the land, was home to the Giants beginning in 1890. They shared the stadium with the Yankees (1913–1922), the football Giants (1925–1955), and the NFL's Bulldogs (1949). It was also used for boxing matches and soccer. Ironically polo was never played there. Yankee Stadium is visible in the upper right. (Courtesy author's collection.)

WESTERN UNION

CLASS OF SERVICE

This is a fast message unless its deferred character is indicated by the proper symbol.

TELEGRAM

W. P. MARSHALL, PRESIDENT

1201

SYMBOLS

DL=Day Letter
NL=Night Letter
LT=International Letter Telegram

The filing time shown in the date line on domestic telegrams is STANDARD TIME at point of origin. Time of receipt is STANDARD TIME at point of destination

MAR 5 1959 G &-4 PD HORACE STONEHAM

SAN FRANCISCO GIANTS C/O ADAMS HOTEL PHOENIX ARIZONA

DODGERS AND YANKEES PLAY IN EXHIBITION GAME FOR

CAMPANELLA MAY 7 NIGHT IN LOS ANGELES

WE PLAY GIANTS THAT AFTERNOON IN SAN FRANCISCO

AND WILL FLY TO LOS ANGELES BUT WILL SHOW UP FOR YOUR

NIGHT GAME MAY 8 THOUGHT YOU WOULD LIKE TO KNOW

WALTER F O'MALLEY DODGERTOWN
VERO BEACH FLORIDA 3:29 PM

THE COMPANY WILL APPRECIATE SUGGESTIONS FROM ITS PATRONS CONCERNING ITS SERVICE

Rivals on the field, Horace Stoneham and the Dodgers' Walter O'Malley were always cordial off the field. In August 1957, the Giants' stockholders decided to move to San Francisco, but the Dodgers did not receive a formal offer from the Los Angeles City Council until October 1957. Much has been written, however, that O'Malley moved to Los Angeles before convincing Stoneham to follow. (Courtesy Rick Swig.)

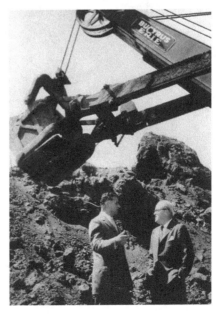

On August 19, 1957, the stockholders of the National Exhibition Company (the owners of the New York Giants) voted 8–1 to move the team to San Francisco. Three days later, president Horace Stoneham, right, and San Francisco mayor George Christopher visited the site chosen for the new stadium. Actual construction did not begin until a year later. (Courtesy San Francisco History Center, San Francisco Public Library.)

John Bolles joined his father's firm in 1936 with a civil engineering degree and a masters in architecture from Harvard. Edward Bolles started the firm in 1905, and after the 1906 earthquake it flourished. John Bolles and his partner, J. Francis Ward, were the first to erect a concrete structure using the tilt-up method. John's son Peter joined the firm in the 1960s. (Courtesy Jane Bolles Grimm.)

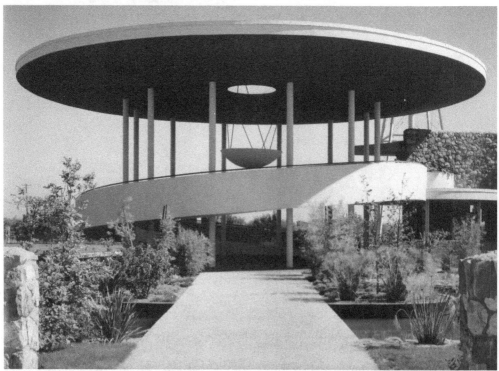

A curving ramp led to the visitor entrance of the ultra-modern Paul Masson Champagne Cellar in Saratoga. John Bolles, who specialized in commercial and industrial buildings, primarily in northern California, designed this award-winning complex in 1959. Ansel Adams, a friend of Bolles, and colleague Pirkle Jones then documented its construction for the owners. Bolles designed all of the suburban Macy's stores in the Bay Area. (Courtesy Jane Bolles Grimm.)

Architect John Bolles examines a 1/32 model of the stadium that shows the stands and roof on the west side extending the length of the third base line and 150 feet into left field. This original plan would have diminished the westerly and northwesterly winds. The size of the final structure was reduced by the city for economic reasons. (Courtesy San Francisco History Center, San Francisco Public Library.)

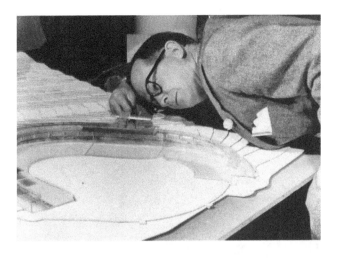

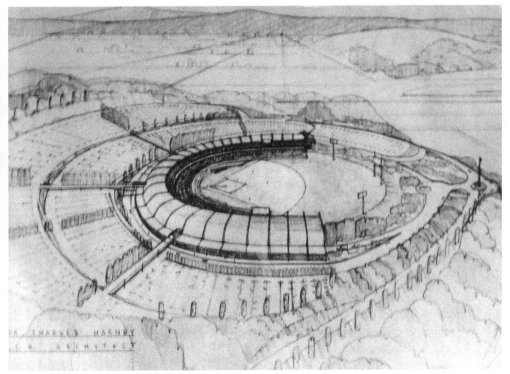

John Bolles's aerodynamic roof concept, shown on August 11, 1957, was designed to cover most of the stands to reduce the effects of the wind. The engineering firm, Horkey-Moore Associates, thought that it would be effective but then the structural plan was reduced due to budget concerns. Supervisor Clarissa McMahan had insisted that something be done to solve the wind problem. (Courtesy San Francisco History Center, San Francisco Public Library.)

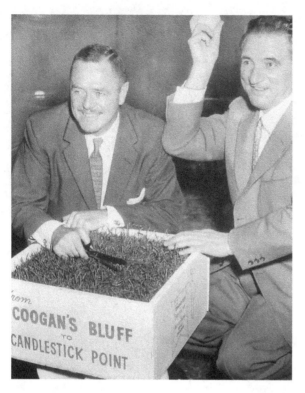

Supervisor Francis McCarty, left, and Mayor George Christopher display turf from the Polo Grounds in 1957. Mayor Elmer Robinson backed by *San Francisco Examiner* sports editor Curley Greive aspired to bring Major League Baseball to San Francisco in 1953. They sought an American League team because popular local players Lefty O'Doul and Joe DiMaggio played in that league. (Courtesy San Francisco History Center, San Francisco Public Library.)

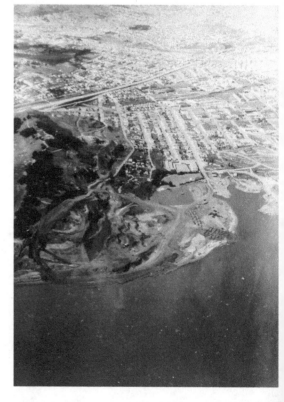

Candlestick Point was quarried to provide fill material and to prepare the area for construction. To the far left is Jamestown Avenue, which was built to provide access to the stadium. Bolles's decision to locate the stadium on the bedrock of the hill provided a strong footing and was critical to how little damage it suffered during the 1989 Loma Prieta earthquake. (Courtesy San Francisco History Center, San Francisco Public Library.)

CANDLESTICK POINT

The Giants began to play in San Francisco on April 15, 1958, at Seals Stadium against the Los Angeles Dodgers. First baseman Orlando Cepeda hit his first home run in the major leagues, and the Giants won 8-0. Cepeda won Rookie of the Year in 1958. During that first year for both California teams, the Giants beat the Dodgers 16 of 22 games. (Courtesy Rick Swig.)

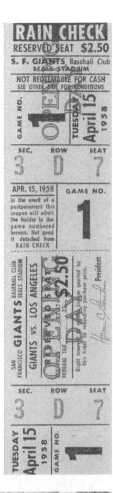

Seals Stadium was constructed in 1931 of steel and concrete and had an art deco design common for the era. It originally held 18,600 but was expanded twice and held 22,900 during the Giants' time there. As can be seen, there was no warning track. Seals Stadium was demolished after the 1959 season. A retail center and Dolby Laboratories now occupy the site. (Courtesy Andrew Holloway.)

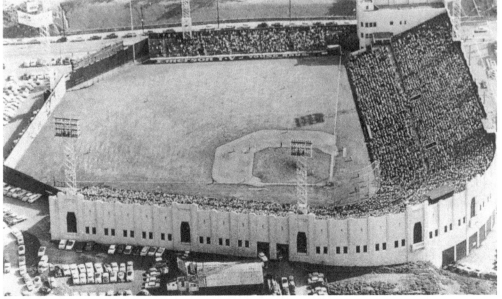

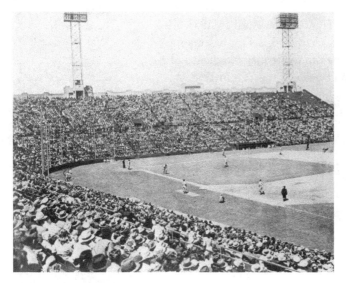

Adding a second deck to Seals Stadium was considered but it was found that the structure would not support the weight. Also, the industrial area was not spacious enough to build the parking lots promised to Horace Stoneham, and the park across the street was deeded to the city to be used as a park, its ownership reverting to the heirs if it was used otherwise. (Courtesy Andrew Holloway.)

The Hamm's Brewery was across the street from Seals Stadium and its large neon beer glass sign was a San Francisco landmark. The glass, seen from the nearby Central Freeway, would empty and fill at night. The Hamm's Brewing Company ceased operations at the plant in 1973. The sign is now gone but the building remains and is divided into office and retail space. (Courtesy Rick Swig.)

Surveyors Oliver Bell (facing camera) and Arner Hermanson began to configure Candlestick Park on January 29, 1958. Owner Horace Stoneham and the city completed their agreement on February 7 and the final settlement in July, when Stoneham agreed to a 35-year lease and the larger of $125,000 rent or 5 percent of the gross, parking revenue to the city, and television receipts to the Giants. (Courtesy San Francisco History Center, San Francisco Public Library.)

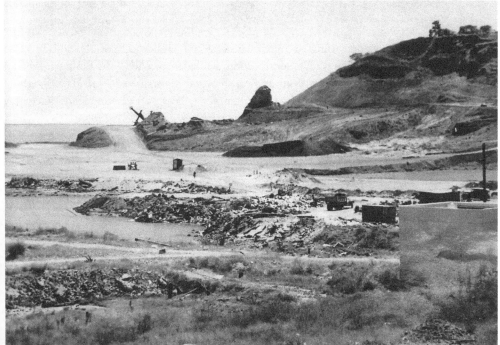

The site for Candlestick Park required 77 acres: the city owned 31 acres; 5 were purchased from other owners for $6,540 per acre, and 41 acres were purchased from Charles Harney for $63,853 per acre ($2.7 million). Harney had purchased this land from the city in 1953 for $2,100 an acre, giving him a profit of $2,613,000. In 1958, the sale by Harney prompted a grand jury investigation. (Courtesy San Francisco History Center, San Francisco Public Library.)

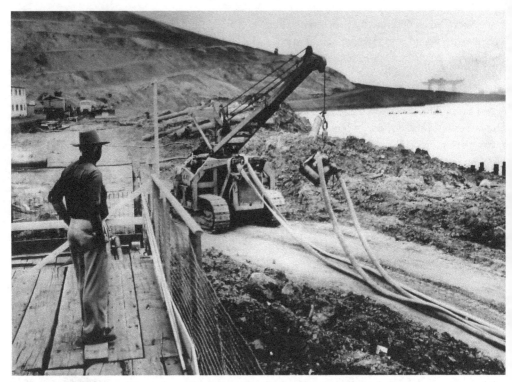

In June 1958, William Manuel watched from the deck of his Candlestick Cove home, one of the few buildings that stood in the way of construction, while Harney Way, the main access road from the south, was being built. Quarrying and construction in this area disturbed the Bayshore Mound, a 5,000-year-old refuse site left by the Costanoan tribe of Native Americans. (Courtesy San Francisco History Center, San Francisco Public Library.)

Tractors pushed dirt to a conveyor belt as Bayview Hill was partially removed for Candlestick Park. In total, 6 million cubic yards of earth were moved. Charles Harney, a third-generation contractor, was experienced in the construction of highways, dams, streets, and bridges. He also had a strong interest in sports and was a major benefactor of the University of San Francisco. (Courtesy San Francisco History Center, San Francisco Public Library.)

Construction began in September 1958. The drill in the center is the location of home plate with the pitcher's mound off to the left. There was growing conflict between contractor Charles Harney and the city about who would pay for unplanned costs such as the complete fill of tidelands. (Courtesy San Francisco History Center, San Francisco Public Library.)

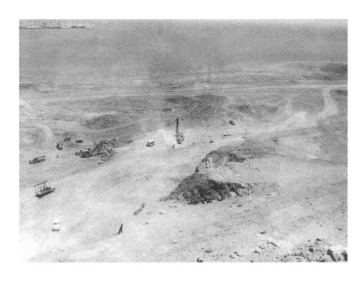

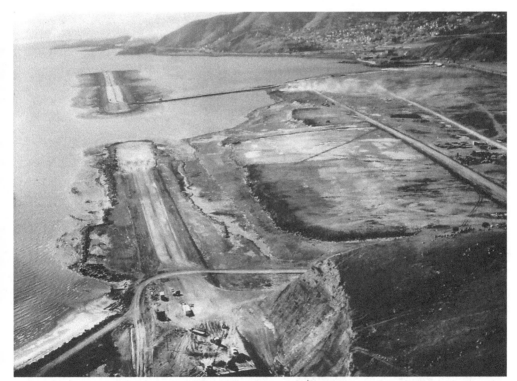

The Candlestick Causeway for the Bayshore Freeway (US101) between San Francisco and South San Francisco was under construction in 1955. It was dedicated in 1957 and ultimately replaced the Bayshore Highway to the west. Stadium traffic from the south exited at Candlestick Park onto Harney Way and then to the stadium. (Courtesy San Francisco History Center, San Francisco Public Library, and California Division of Highways.)

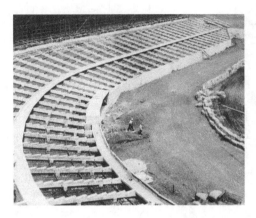

Grade beams were in place on April 30, 1959, and precast seat supports, in 24-foot length slabs, topped them, making Candlestick Park the first stadium in the country built entirely of reinforced concrete. Contractors were hired based on their experience with concrete, and architect John Bolles was considered an innovator in the use of concrete because he had helped design the first tilt-up concrete building. (Courtesy San Francisco History Center, San Francisco Public Library.)

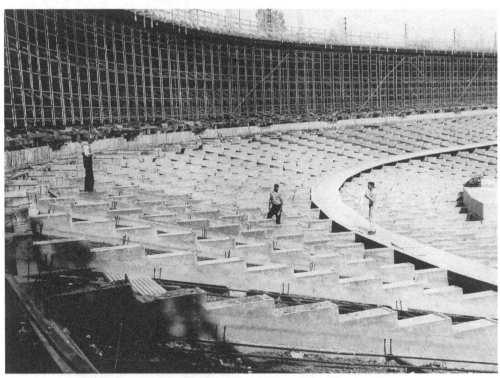

Radiant heat pipes were visible under the seat slabs, but the seat-heating system never worked correctly as the pipes were not embedded in the concrete. It was thought the heating system would make it warm on the coldest of nights and the rising heat currents would diminish the wind. (Courtesy San Francisco History Center, San Francisco Public Library.)

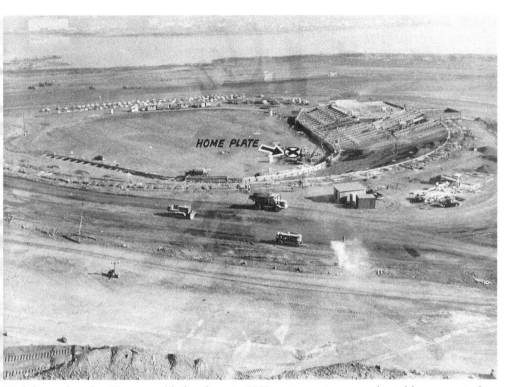

With hope that the Giants could play there in 1959, construction moved quickly, as seen in late 1958. Excavating that permitted mid-height entrance would allow fans to enter via a bridge to the main concourse, putting them at the top of the main stands. All other stadiums of the era had field-level entry, necessitating a walk up to all seats. (Courtesy San Francisco History Center, San Francisco Public Library.)

The 80-foot-deep fill for Jamestown Avenue kept sinking during construction, costing Charles Harney an additional $500,000. The street, which was designed to carry a heavy load of transit buses, was planned to serve the stadium as the main north-south artery for the site. (Courtesy San Francisco History Center, San Francisco Public Library.)

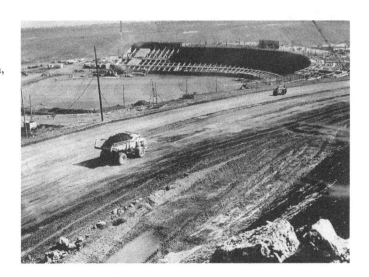

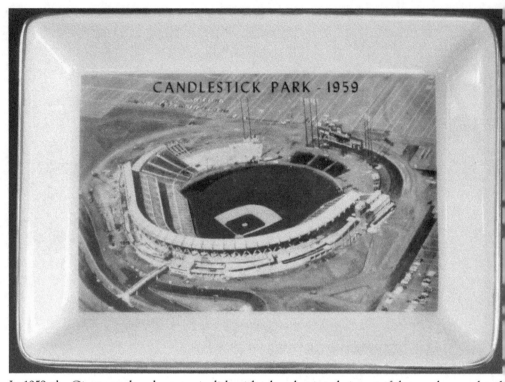

In 1959, the Giants produced a ceramic dish with a hand-painted picture of the nearly completed Candlestick Park. The dish was sent to season ticket holders with the hope that they would continue to purchase tickets at the new stadium. (Courtesy author's collection.)

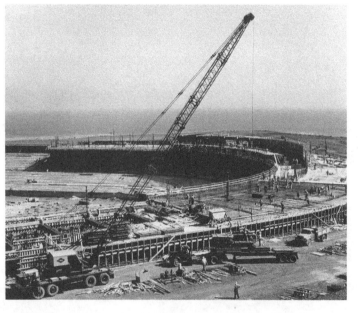

The lower level complete, work was taking place on the promenade level. The press box and radio booths were located on this level, as were exclusive loge seats in boxes enclosed on all sides except those facing the field. In the mid-1980s, these boxes were converted to suites. Space was left on this level and was allotted for the Stadium Club and Hofbrau. (Courtesy Jane Bolles Grimm.)

The main structure was nearing completion on August 31, 1959. The Giants were leading the National League, and a plan was made to play the World Series at Candlestick when it was hoped that 30,000–40,000 seats would be ready. Unfortunately September was a bad month for the Giants, and they ended up in third place, four games behind the Los Angeles Dodgers. (Courtesy Jane Bolles Grimm.)

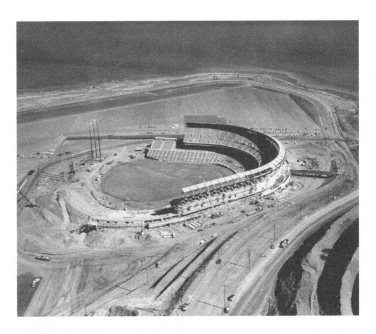

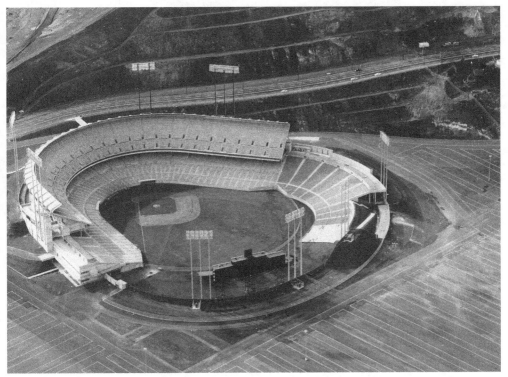

An aerial view of the completed stadium shows the clean, modern lines of Bolles's design. He was a minimalist in the use of materials and used concrete to its limits. The structure blends into Bayview Hill, yet the concourses and open outfield areas provide views of San Francisco Bay and the city. (Courtesy Jane Bolles Grimm.)

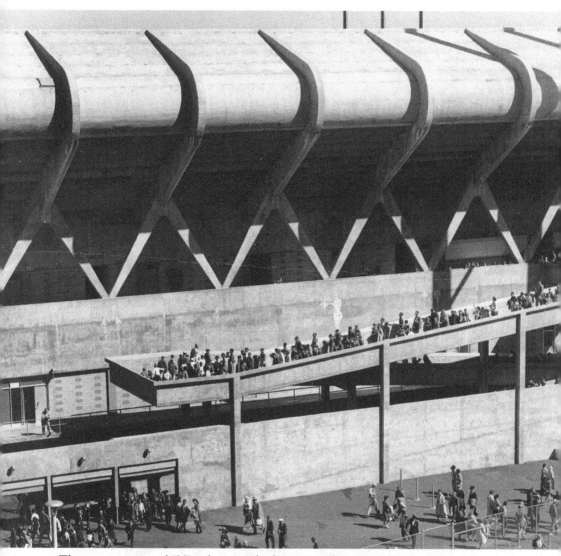

The precast inverted "V" columns, which support the top of the upper tier, were designed to handle horizontal and vertical loads. The boomerang-shaped units support the curved roof that was designed as a wind baffle. The boomerang shape and the roof that appears to float are indicative of Googie architecture, a type of Modernism. Other than Dodger Stadium, built two years after Candlestick, no other stadiums built in the 1960s and 1970s had the futuristic look of Candlestick Park. Architectural critic and author Alan Hess said, "Bolles took that airfoil form and made the most of it as a Modernist cap to the building. The way Bolles made all these Modern shapes work together is what makes it a great modern design. JB Jackson, the great geographer, talked about spectacle—the way modern sports orchestrates color, noise, action, emotion, light into a spectacle that lifts people into a heightened state. The architecture of Candlestick goes along with that with its muscular, tense energy. It is a stage for a performance that includes the audience." (Courtesy Jane Bolles Grimm.)

In the late 1920s, Bolles worked for the Carnegie Institute on a Mayan archaeological study at Chichen Itza in the Yucatan in Mexico. Bolles took this photograph of the interior side of the roof facade at La Iglesia Las Monjas. He then used the same idea that the Mayans had used 1,000 years before to support the roof of his 20th-century building. (Courtesy Jane Bolles Grimm.)

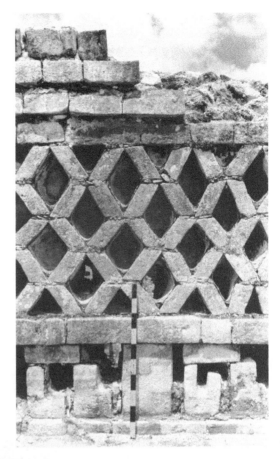

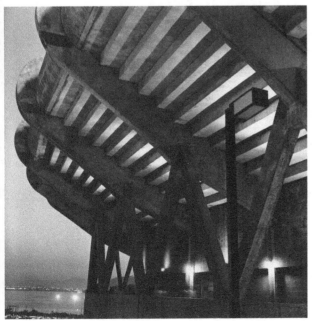

By exposing the precast concrete boomerang roof support units and V-shaped columns, Bolles created a dramatic modern look; older stadiums hid the "skeleton" of their buildings behind facades. Restrooms, concessions, and access ramps were located on the outside of the main structure so that once fans were ready, they entered the seating area ready to get down to the business of enjoying a game. (Courtesy Jane Bolles Grimm.)

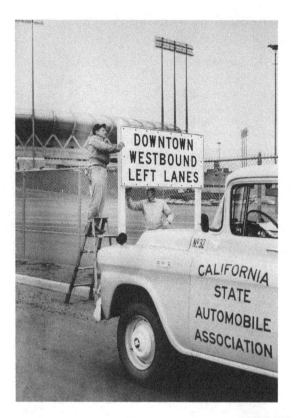

As part of the finishing touches, the California State Automobile Association was paid to post parking and traffic signs around the stadium. (Courtesy San Francisco History Center, San Francisco Public Library.)

The June 1960 edition of *The Californian* included an extensive article on the financing and construction of Candlestick Park. Not including streets and utilities, the cost exceeded $15 million, much higher than the $5 million bond passed in 1954. The article used the 1958 grand jury report that concluded a good deal for Charles Harney, a bad one for the city. (Courtesy San Francisco History Center, San Francisco Public Library.)

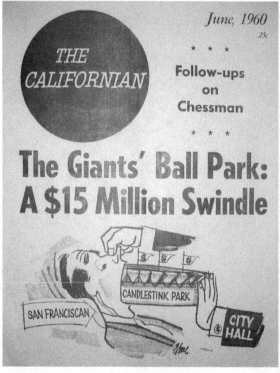

The Finest Ballpark
in America

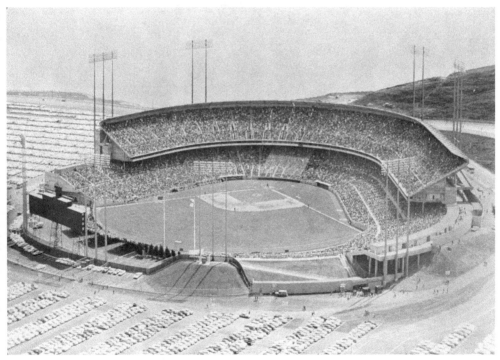

Candlestick Park opened on April 12, 1960, against the St. Louis Cardinals. It was the first stadium ever built specifically for a major-league team (baseball or football) west of St. Louis. Its capacity was 42,500, and it was the only all-concrete stadium in the majors. J G Taylor Spink, publisher of the *Sporting News*, wrote, "Candlestick Park is simply wonderful, marvelous, unbelievable. Baseball has never known anything like it." (Courtesy Charlie Hallstrom.)

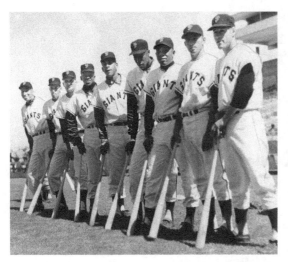

On opening day, April 12, 1960, the Giants lined up against the St. Louis Cardinals. In batting order are, from right to left, Don Blasingame, second baseman; Jim Davenport, third baseman; Willie Mays, center field; Willie McCovey, first baseman; Orlando Cepeda, left fielder; Willie Kirkland, right fielder; Eddie Bressoud, short stop; Bob Schmidt, catcher; and Sam Jones, pitcher, who pitched a complete game for a 3-1 victory. (Courtesy San Francisco History Center, San Francisco Public Library.)

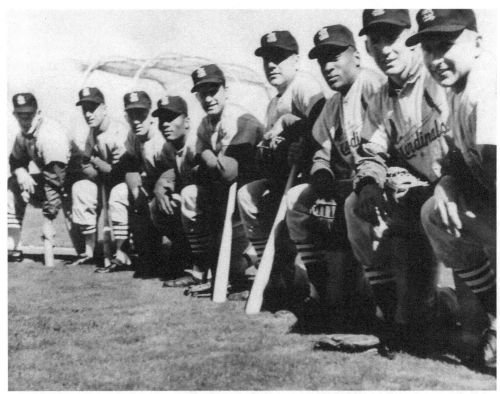

The opponents on opening day in 1960 were the St. Louis Cardinals. Pictured in batting order from right to left are Joe Cunningham (left fielder), Daryl Spencer (short stop), Bill White (center fielder), Ken Boyer (third baseman), Stan Musial (first baseman), Leon Wagner (left fielder), Hal Smith (catcher), Alex Grammas (second baseman), and Larry Jackson (pitcher). Bill White played for the Giants in 1958 and later became the president of the National League. (Courtesy San Francisco History Center, San Francisco Public Library.)

Arrival by boat was a unique occurrence at Candlestick Park, as can be seen on opening day in 1960. Hilary Bezloc, 57, the owner of the sailboat in the photograph, became the first person to require first aid when he lost the tip of his ring finger in the anchor chain of his 31-foot boat. (Courtesy San Francisco History Center, San Francisco Public Library.)

Eight heart attacks occurred during the stadium's first month, giving its west side the name "Cardiac Hill." The taxi ramp was intended to eliminate the uphill walk, but the police would not allow passenger drop-off. Special parking and a different drop-off point were established in May, which shortened the uphill climb. This accommodation occurred 30 years before the Americans with Disabilities Act passed. (Courtesy San Francisco History Center, San Francisco Public Library.)

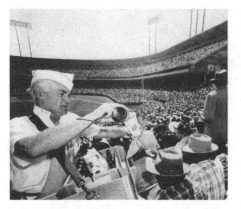

The Falstaff beer being poured by vendor Ed Griffin sold for 40¢. When Candlestick opened, concessionaire Harry Stevens employed 175 vendors and another 125 behind-the-scenes workers. Stevens first sold rolls of "dachshund sausages" in 1901 at New York Giants games, urging fans to get them while they were "red hot"; but it is believed a newspaper cartoonist could not spell dachshund so nicknamed the sausages "hot dogs." (Courtesy San Francisco History Center, San Francisco Public Library.)

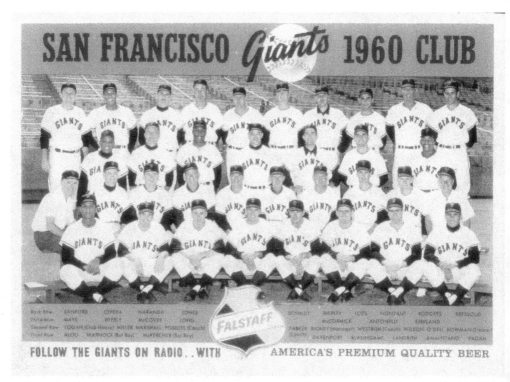

Locally brewed beer companies were early sponsors of the Giants. The Falstaff Brewing Corporation of St. Louis, for example, first sold beer in California in 1952 when the company purchased the former Wieland's Brewery (established 1856) in San Jose. In 1971, Falstaff moved their production to San Francisco and remained there until 1978. Eventually purchased by Pabst, Falstaff had completely disappeared from the marketplace by 2005. (Courtesy author's collection.)

REFRESHMENT PRICE LIST

Sandwiches

Turkey	50c	Ham	50c
Swiss Cheese	50c	Salami	50c
Egg	50c	Tuna	50c
Corned Beef	75c	Box Lunch	$1.25

Other Refreshments

Frankfurter & Roll	30c
Hamburger on Bun	60c
Hot Pizza (slice)	30c
Cake	20c
Potato Chips	15c
Corn Chips	15c
Popcorn	15c & 25c
Peanuts	15c
Candy	10c
Gum	5c
Ice Cream Sundae Cup	25c
Ice Cream Sandwich	20c
Ice Cream Frostick Bar	15c
Hot Chocolate	15c
Milk	20c
Coffee	15c
Beer	40c
Soft Drinks	15c & 25c
Cigarettes, Filter, King or Regular	35c
Cigars	15c to 40c
Score Book	20c
Pencil	10c

All Prices Include Cailfornia Sales Tax
Where Applicable

STEVENS CALIFORNIA ENTERPRISES, INC., CANDLESTICK PARK

Compared to modern-day stadiums, the choice of food and souvenirs was limited when Candlestick Park opened. As pointed out by *San Francisco Examiner* columnist Prescott Sullivan, the average purchase price of a hot dog, a beer, and a bag of peanuts was 85¢, but only 60¢ when a soft drink was substituted for the beer. The *San Francisco News-Call Bulletin* did a detailed study of the concession offerings and found that the hot dogs came 10 to the pound and were 6 inches long. It was expected that 300,000 pounds of the franks would be sold in the first season. They also found there were 24 to 26 peanuts in each bag. (Courtesy Rick Swig.)

Al Dermody (left), the winner of the stadium-naming contest, is pictured with Lorie Thiret, a travel agent who provided a trip to St. Louis for the winner, and Walter Haas, representing the Recreation Department. Dermody derived the name Candlestick Park from the point of land where the stadium is located. Haas was the CEO of the Levi Strauss Company and was later the owner of the Oakland Athletics. (Courtesy San Francisco History Center, San Francisco Public Library.)

A dedication dinner was held in the Garden Court of the Sheraton-Palace Hotel the night before opening day 1960. Among the attendees were Vice Pres. Richard Nixon, Gov. Edmund G. "Pat" Brown, and commissioner Ford Frick. Unusual in liberal San Francisco, Nixon was cheered the next day while democrat Brown was booed; the crowd was angry with Brown for not granting clemency to the "Red Light Bandit" Caryl Chessman. (Courtesy Rick Swig.)

The order of speakers . . .

Mayor George Christopher
Governor Edmund G. Brown
Ford Frick
Horace C. Stoneham
Warren Giles
Joseph Cronin
Bill Rigney
Vice President Richard M. Nixon

At the head table . . .

Vice President and Mrs. Richard M. Nixon
Governor and Mrs. Edmund G. Brown
Mayor and Mrs. George Christopher
Larry Barlott, Treasurer, Major League Baseball Committee
John S. Bolles, Architect for Candlestick Park
Alan K. Browne, President, Stadium Inc.
Wm. M. Coffman, San Francisco Recreation and Park Commission
Joseph Cronin, President, American League
Sherman Duckel, Chief Administrative Officer, City and County of San Francisco
Dr. Charles A. Ertola, President, San Francisco Board of Supervisors

Ford Frick, Commissioner of Baseball
Warren Giles, President, National League
Thomas Gray, Dinner Chairman and Secretary, Major League Baseball Committee
Charles L. Harney, Contractor for Candlestick Park
Dion R. Holm, Attorney, City and County of San Francisco
Judge Francis McCarty, Chairman, Major League Baseball Committee
Mrs. John J. McGraw
Bill Rigney, Manager, San Francisco Giants
Harry D. Ross, Controller, City and County of San Francisco
Horace C. Stoneham, President, San Francisco Giants

Jeff Chandler, Toastmaster

Presentation of Sixth Army Colors and National Anthem by the Sixth Army Band

Dinner sponsored by the Mayor's Committee for the Dedication of Candlestick Park

THE FINEST BALLPARK IN AMERICA

The Hiller Aircraft Company, located in nearby Palo Alto, used the recently completed Candlestick Park to promote their new model E4 helicopter. (Courtesy Mike Gay.)

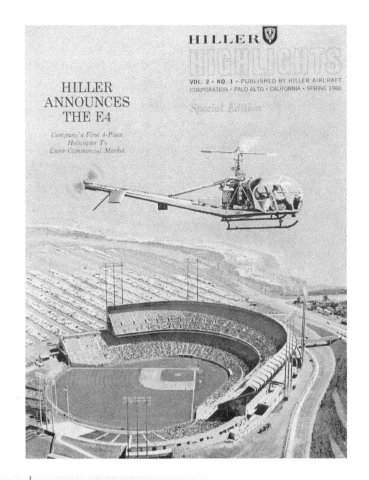

HILLER ANNOUNCES THE E4

Company's First 4-Place Helicopter To Enter Commercial Market

HILLER HIGHLIGHTS

VOL. 2 • NO. 1 • PUBLISHED BY HILLER AIRCRAFT CORPORATION • PALO ALTO • CALIFORNIA • SPRING 1960

Special Edition

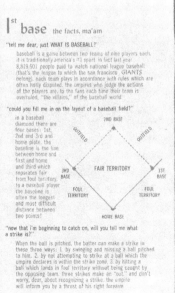

Ist base the facts, ma'am

"tell me dear, just WHAT IS BASEBALL?"

baseball is a game between two teams of nine players each. it is traditionally america's #1 sport. in fact last year 8,819,501 people paid to watch national league baseball (that's the league to which the san francisco GIANTS belong). each team plays in accordance with rules which are often hotly disputed. the umpires who judge the actions of the players are, to the fans each time their team is overruled, "the villains," of the baseball world.

"could you fill me in on the layout of a baseball field?"

in a baseball diamond there are four bases: 1st, 2nd and 3rd and home plate. the baseline is the line between home and first and home and third which separates fair from foul territory, to a baseball player the baseline is often the longest and most difficult distance between two points!

"now that i'm beginning to catch on, will you tell me what a strike is?"

When the ball is pitched, the batter can make a strike in these three ways: 1. by swinging and missing a ball pitched to him. 2. by not attempting to strike at a ball which the umpire declares is within the strike zone. 3. by hitting a ball which lands in foul territory without being caught by the opposing team. three strikes make an "out." and don't worry, dear, about recognizing a strike. the umpire will inform you by a thrust of his right forearm.

"what is the strike zone?"

the area between the batter's knees and shoulders extending out over home plate.

"then what for goodness sake is 'a ball'?"

it is called "a ball" when the pitcher throws outside of the strike zone and the batter doesn't attempt to strike at it. if the umpire calls four balls while the same batter is at bat that batter is allowed to proceed to 1st base, and again, dear, don't worry about your having to recognize "a ball" unaided, the umpire will keep his arms down.

"what game do women baseball fans like to play which involves 15 bases, an absolutely limitless field of play, and a complete absence of rules?"

the shopping game, of course, at all of the 15 JOSEPH MAGNIN stores, every bit of the action in that game brings a hit!

"I'm not very good at mathematics so can you possibly tell me how a batting average is figured?"

divide the number of times the baseball player is "at bat" into the number of hits he has made. for instance, if he is "at bat" 10 times and gets 3 hits, his batting average is .300.

"since you seem to know all the answers, perhaps you can tell me how the 1958 baseball season will come out?"

here's a suggestion which can make your baseball season really fun. grab a copy of the SPORTS ILLUSTRATED special baseball issue. it's crammed with information about every team, up toward the front you'll find a place to enter your own predictions on how the teams will finish. keep referring to them as the season goes along, before long you'll start to see a pattern develop and lo and behold you yourself may end up being the best predictor of them all when the season is finished.

Sports Illustrated and Joseph Magnin stores published "just tell me dear, WHAT IS BASEBALL?" Joseph Magnin was a high-end women's-wear store that pursued the younger women's market after World War II. Marilyn Monroe shopped at Joseph Magnin for the suit she wore when she married Joe DiMaggio in 1954. (Courtesy Rick Swig.)

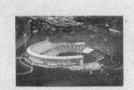
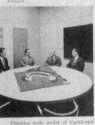

Westinghouse used Candlestick Park in this four-page advertising spread. Westinghouse equipment and design were used for Candlestick's lighting and other electrical service as well as air-handling equipment. (Courtesy Mike Gay.)

Members of the San Francisco Police Department's traffic division watched from Bayview Hill during a game against the Chicago Cubs on April 17, 1960. The officers are, from left to right, Capt. Edward Moody, Lt. Edward Cummins, and director of traffic Thomas Zaragoza. (Courtesy San Francisco History Center, San Francisco Public Library.)

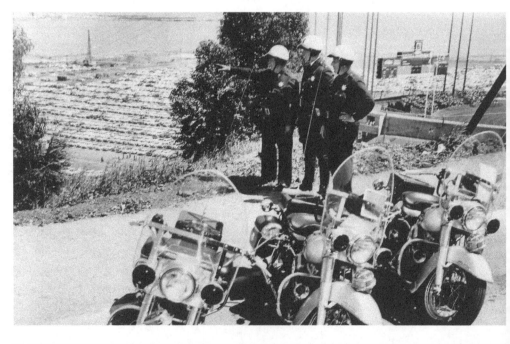

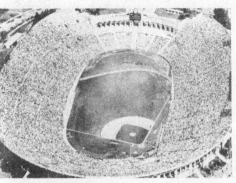

WHERE THEY PLAY

SAN FRANCISCO
Candlestick Park—Capacity 42,500
Distance from plate to right field ... 335
Distance from plate to left field ... 335
Distance from plate to center field ... 420

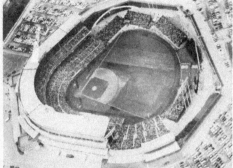

LOS ANGELES Coliseum—capacity 102,000
Distance from plate to right field ... 302
Distance from plate to left field ... 250
Distance from plate to center field ... 450

42

MILWAUKEE County Stadium—capacity 43,760
Distance from plate to right field ... 320
Distance from plate to left field ... 320
Distance from plate to center field ... 450

The first two decades of the 20th century comprised the golden age of stadium construction; only Cleveland Municipal Stadium, opened in 1931, was built later. The Los Angeles Memorial Coliseum was the Dodgers' temporary home for four years. Milwaukee County Stadium was built in 1953, Wrigley Field in 1914, Crosley Field in 1912, Connie Mack and Forbes Field in 1909, and Sportsman's Park in 1902. (Courtesy Rick Swig.)

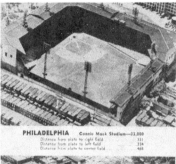

PHILADELPHIA Connie Mack Stadium—33,000
Distance from plate to right field ... 331
Distance from plate to left field ... 334
Distance from plate to center field ... 468

NATIONAL LEAGUE BALL PARKS

ST. LOUIS Busch Stadium—capacity 32,965
Distance from plate to right field ... 310
Distance from plate to left field ... 351
Distance from plate to center field ... 422

PITTSBURGH Forbes Field—capacity 32,730
Distance from plate to right field ... 300
Distance from plate to left field ... 335
Distance from plate to center field ... 457

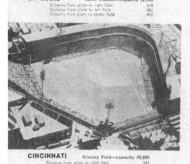

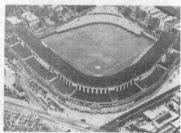

CINCINNATI Crosley Field—capacity 30,000
Distance from plate to right field ... 342
Distance from plate to left field ... 328
Distance from plate to center field ... 387

CHICAGO Wrigley Field—capacity 38,690
Distance from plate to right field ... 353
Distance from plate to left field ... 355
Distance from plate to center field ... 400

43

Entrees

First Run	Brook Trout · · · · · · ·	4.00
	Colorado Boneless, Sauté Meuniere, Vegetable du Jour	
	World Finest Trout fresh from Springfed Rocky Mountain Waters	
Second Run	Minute Steak · · · · · · ·	4.50
	Served with our Special Mustard Sauce	
Third Run	Prime Rib of Beef · · · · · ·	5.15
	In its Own Natural Juice with Home-made Horseradish Sauce	
Fourth Run	New York Steak · · · · · ·	5.40
	Properly Aged Selected Steer Beef, Specially Cut and Trimmed, with Maitre d'Hotel Butter	
Fifth Run	Filet Mignon · · · · · ·	5.95
	Selected for Tenderness, Served with Mushroom Sauce, Vegetable du Jour	
Sixth Run	Chicken - Charcoal Broiled · · · ·	4.15
	Milk Fed, Country Fresh, Served on Toast with Rasher of Bacon, Peach Glacé	

Fresh French Rolls served with all Entrees

The Stadium Club, a restaurant and bar, was located on the Promenade Level of Candlestick Park. The original plan was to sell annual memberships for $15 to box and season ticket holders, but a change in the law allowed the club to be open to everybody. There was no view of the field, however, as Horace Stoneham did not think people should watch the game from a club. (Courtesy Rick Swig.)

EXPRESS VIA 19TH AVE.
FIRST STOP — GENEVA & MISSION,
THENCE AT GENEVA & SAN JOSE, OCEAN & PHELAN,
OCEAN & JUNIPERO SERRA,
THENCE ONLY AT TRANSFER POINTS ALONG
LINE NO. 28 TO 25TH & CALIFORNIA

The San Francisco Municipal Railway had five bus lines to Candlestick Park: two were regular routes and three were express routes. The stadium was more than 1 mile away from the Southern Pacific Railroad tracks (now Caltrain) and there was no direct access to the station. It was also far from the San Francisco Municipal Railway streetcar system. As a result, most fans arrived in private vehicles. (Courtesy San Francisco History Center, San Francisco Public Library.)

THE FINEST BALLPARK IN AMERICA

Willie Mays batted against the Tokyo Yomiuri Giants in Tokyo during the Giants' 1960 trip to Japan. The all-time leader in home runs, Sadaharu Oh with 868 runs, was playing for the Yomiuri Giants at this time. The Giants played 16 games during their one-month trip to Japan in October and November 1960. (Courtesy Kerry Yo Nakagawa and Nisei Baseball Research Project.)

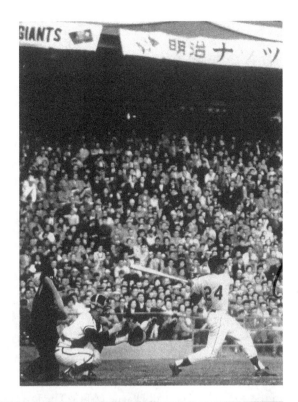

Prince Akihito and his wife, Michiko, meet with Horace Stoneham during the 1960 visit. To Stoneham's left is manager Tom Sheehan and to his right is Tsuneo "Cappy" Harada, a Nisei who managed the Tokyo Giants and was a special assistant to Stoneham. Stoneham was revered in Japan, and in 1970, Emperor Hirohito awarded him The Supreme Order of the Chrysanthemum, the nation's highest honor. Akihito became emperor in 1989. (Courtesy Rupert family.)

The field was set for Candlestick Park's first football game on December 4, 1960, also the first year of the American Football League (AFL). The Los Angeles Chargers would defeat the Oakland Raiders 41-17. After beginning their season with five games at Kezar Stadium, the Raiders moved to Candlestick and then finally to Oakland after the 1961 season. Charles Harney, who built Candlestick, was also part owner of the Raiders. (Courtesy author's collection.)

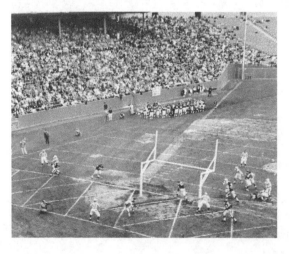

Los Angeles Chargers quarterback Jack Kemp completed the first touchdown pass at Candlestick Park. Kemp later became a cabinet secretary and a vice presidential candidate. His son Jeff played quarterback for the 49ers in 1986. Also in this game were Raiders quarterback Tom Flores, who later became their head coach, Chargers assistant coach Al Davis, and Chargers head coach Sid Gillman, the "Father of the Modern Passing Game." (Courtesy author's collection.)

THE FINEST BALLPARK IN AMERICA

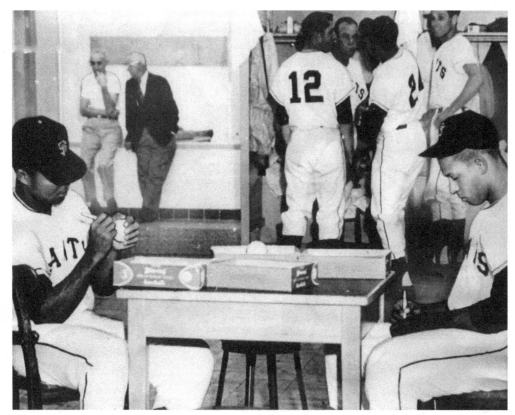

Pictured in 1960 signing baseballs are outfielder Felipe Alou (left) and first baseman Orlando Cepeda (right). In the background are Jim Davenport (12), Willie Mays (24), Billy O'Dell, and Eddie Broussaud (far right). Horace Stoneham was the first owner to heavily scout and sign players from the Dominican Republic, including Alou and Juan Marichal (Hall of Fame, 1983). In addition, Stoneham signed Cepeda (Hall of Fame, 1999) and Jose Pagan from Puerto Rico. (Courtesy San Francisco History Center, San Francisco Public Library.)

Kids waited at the left field gate on a Tuesday afternoon in 1962. Tuesdays were Kids' Days, when all kids ages 9 to 14 were admitted free of charge to enjoy a game. In all, 140,000 kids attended games that year. (Courtesy San Francisco History Center, San Francisco Public Library.)

CANDLESTICK PARK 49

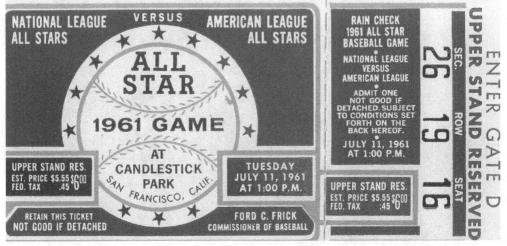

At the time, two All-Star games were played each season. The first game in 1961 was at Candlestick Park on July 11. Baseball mythology suggests that pitcher Stu Miller was blown off the mound during this game; in reality, he merely lost his balance during a wind gust and the umpire called a balk. The second game, played at Fenway Park, ended in a tie due to a torrential downpour. (Courtesy Rick Swig.)

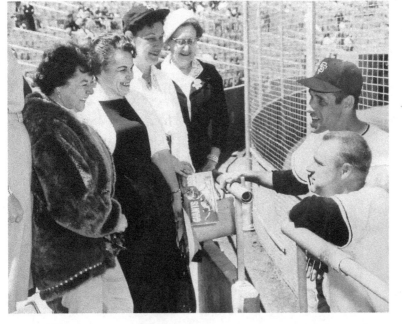

Eddie Bressoud (right, with hat) and Harvey Kuehn chatted with fans at the first ever Ladies' Day on April 13, 1961. Unreserved grandstand seats were 50¢, and reserved seats were $1. (Courtesy San Francisco History Center, San Francisco Public Library.)

THE FINEST BALLPARK IN AMERICA

Mike Schultz of San Jose, ill with a blood deficiency, visited with his hero Willie Mays at a purveyor's night dinner in July 1962 where Mays was a guest speaker in San Jose. Bob Mihlovich, manager of the 1962 Moreland (West San Jose) Little League World Champions, looks on. (Courtesy Schultz family.)

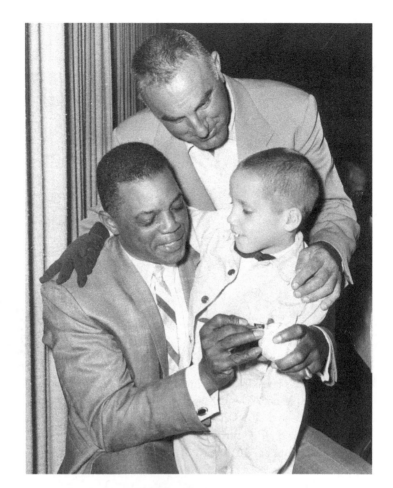

Students from the University Mound School in San Francisco are shown sitting with Sister Claude at a game against the Pittsburgh Pirates on July 13, 1961. They watched Willie Mays score the winning run with a solo home run in the eighth inning for a 2-1 victory. (Courtesy San Francisco History Center, San Francisco Public Library.)

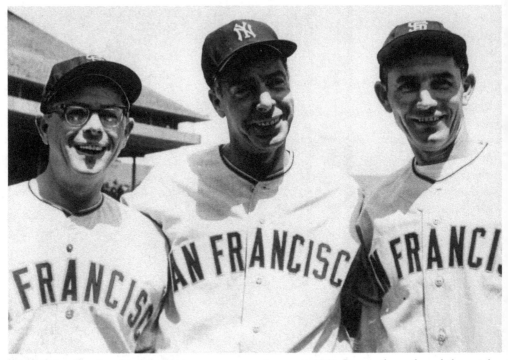

The DiMaggios played in an old-timers game on August 4, 1962. Pictured are, from left to right, Dom, Joe, and Vince. The DiMaggios grew up in San Francisco's North Beach and played for the San Francisco Seals, although only Joe and Vince played at the same time. Dom played his entire career for the Red Sox, Joe for the Yankees, and Vince for the New York Giants in 1946. (Courtesy San Francisco History Center, San Francisco Public Library.)

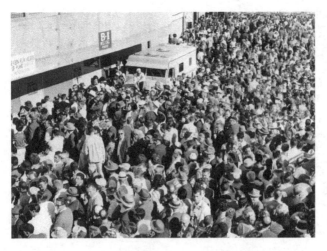

Fans lined up on September 30, 1962, to buy tickets for the first of the three-game playoff series against the Los Angeles Dodgers. The Giants won this game 8-0 but lost game two in Los Angeles. In game three in Los Angeles, the Giants scored four runs in the ninth inning to win 6-4. More than 10,000 fans greeted them at the airport upon their return to San Francisco. (Courtesy Russ Moshier.)

Joe DiMaggio, the "Yankee Clipper" (left), and Yankee owner Del Webb (right) walked on the field before the opening game of the 1962 World Series. This was the first public appearance by DiMaggio since the death of his ex-wife, Marilyn Monroe, two months earlier. The Yankees won the game 6-2. (Courtesy San Francisco History Center, San Francisco Public Library.)

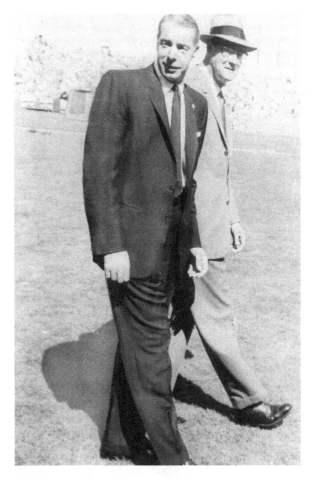

The 1962 World Series was postponed four days between game five in New York and game six at Candlestick Park due to heavy rains. The parking lots were built on tidelands filled in with dirt from the excavation of Bayview Hill, and sinking had been a problem from the time of construction. Flooding still persists as a problem for the 49ers, as more rain falls during the fall than summer. (Courtesy Rick Swig.)

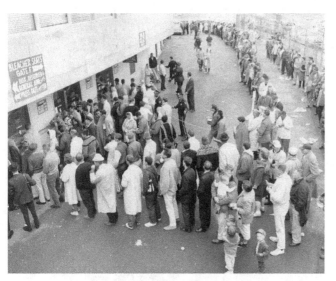

Fans lined up at the box office for tickets to the 1962 World Series. San Francisco received 7 inches of rain from Typhoon Freda, causing the seven-game series to take 12 days to complete. Historically the Giants have played in three of the longest World Series: in 1911 against the Philadelphia A's (rain), in 1962 against the Yankees (rain), and in 1989 against the Oakland A's (Loma Prieta earthquake). (Courtesy Russ Moshier.)

A souvenir vendor's sign tells the story for game seven of the 1962 World Series. Trailing 1-0, there were two outs in the bottom of the ninth, with a man on second and third. At bat, Willie McCovey hit what he described as the hardest ball he ever struck. His line drive was directly at second baseman Bobby Richardson. The Giants did not return to the World Series until 1989. (Courtesy Rick Swig.)

This disclaimer appeared in game programs in 1962, following a breach-of-warranty lawsuit during which attorney Melvin Belli, sporting an Alaskan parka, testified that Horace Stoneham had not turned on the radiant heat at Candlestick Park. An article in the Giants' yearbook had stated that the boxes would be 85 degrees. The jury awarded Belli $1,886.59, but two weeks later Belli placed a lien on Willie Mays and Stoneham's supply of scotch. (Courtesy Rick Swig.)

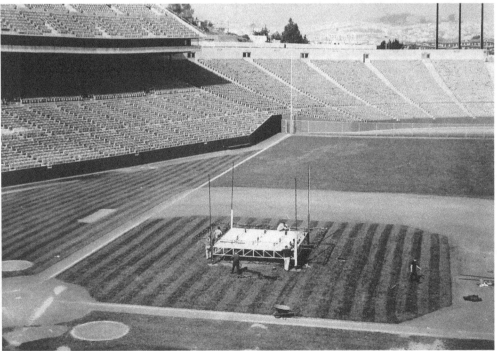

Workmen completed the ring for the World Boxing Association middleweight title fight between Gene Fullmer and Dick Tiger on October 23, 1962. Tiger won in the 15th round of the only boxing match ever held at Candlestick. Attendance was low, however, because the Cuban Missile Crisis was going on and the Warriors were playing their first season opening night at the Cow Palace after having moved from Philadelphia. (Courtesy San Francisco History Center, San Francisco Public Library.)

Wind data was collected and sent to Dr. Jack Cermak at Colorado State University in 1962. He then determined that building the stadium 100 yards to the north would have substantially reduced the wind problem. That location, however, would have necessitated building on seismically unstable and filled tidelands. Other studies showed that the winds, affected by Bayview Hill, were of average speed for San Francisco but prone to extreme gusts. (Courtesy San Francisco History Center, San Francisco Public Library.)

An angled cut through Bayview Hill was suggested in 1963 as a way to reduce the wind problem. John Bolles's original plan had called for rows of eucalyptus trees to be planted on the hill as a windbreak, but the city never planted them. Duane Kupier, Giants second baseman and broadcaster once said, "There is no such thing as Texas Leaguers in Candlestick. They all become pop-ups for the catcher." (Courtesy San Francisco History Center, San Francisco Public Library.)

The Ferrari TRI/61 (8) driven by Stan Burnett led out of a turn during a Sports Car Club of America (SCCA) race on September 15, 1963. The second car was a Chevy-powered Ferrari 625 TRC driven by Danno Raffeto. The distant car was thought to be an Elva MK6 entered by "Bunny" Ribbs, the father of Willie T. Ribbs who was one of the first African American professional race car drivers. (Courtesy Tony Ferrari.)

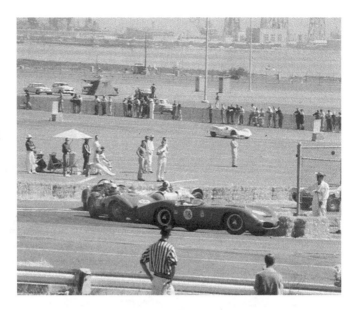

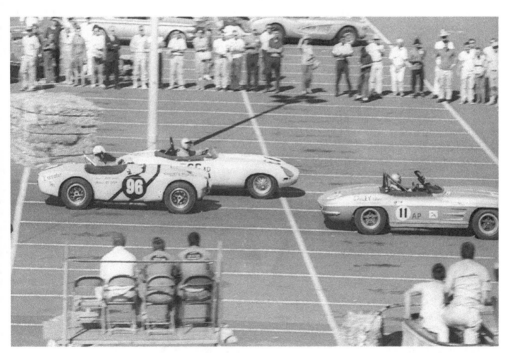

Class A production cars moved out for a practice session on September 15, 1963. The Corvette (11) was driven by Elmer "Red" Faris, the Jaguar E-Type (66) was driven by Merle Brennan, and the Cobra (96) was driven by Allen Grant. Grant's roommate George Lucas did the paint job on the Cobra. Before his interest in filmmaking, Lucas wanted to be a race car driver. (Courtesy Tony Ferrari.)

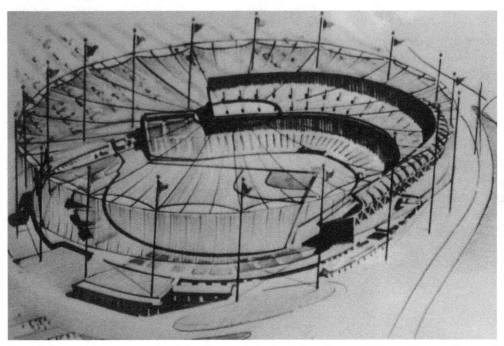

Sam Cohen, a minority owner of the Giants, suggested this plan in 1962 to alleviate the wind problem at Candlestick Park. This $2.3 million fix would wrap the stadium with "Saran Wrap." The architect omitted the light towers so it is not known how well the light might have penetrated the plastic top. (Courtesy San Francisco History Center, San Francisco Public Library.)

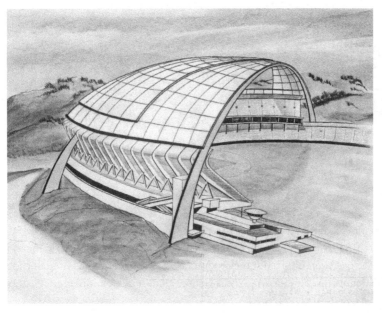

In 1963, the San Francisco firm Lectro-Roof proposed a moveable half-dome fiberglass roof for Candlestick Park. The dome, one of many ideas proposed over the years to deal with the wind, would soar 240 feet over the stands. The estimated cost was over $1 million. (Courtesy Mike Gay.)

THE FINEST BALLPARK IN AMERICA

Workers watched a wrecking ball take the first swing at the Polo Grounds on April 24, 1964, the Giants' home from 1890 to 1957. Other tenants at the 155th Street and Eighth Avenue site had included the New York Mets (1962–1963), the Yankees (1913–1922), the National Football League's Giants (1921, 1925–1955) and Bulldogs (1949), and the American Football League's Titans/Jets (1960–1963). A 30-story apartment complex replaced the Polo Grounds. (Courtesy Rick Swig.)

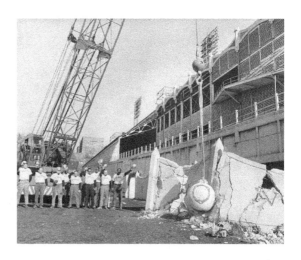

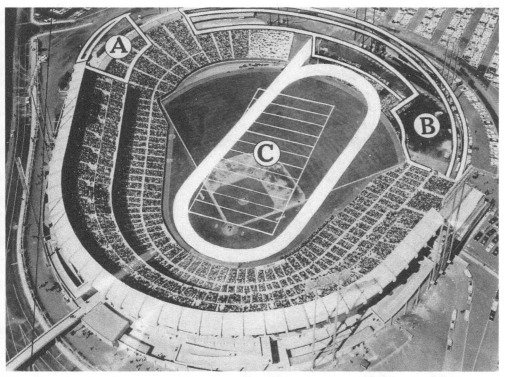

The $5 million bond issue passed by voters in 1954 was for the construction of a multi-sport recreation facility. Although John Bolles's original vision had allowed for football, track, soccer, and baseball, the 49ers were not included in the discussions when the stadium was being built. Several years later, this 1963 plan (pictured) included extensions to the upper (A) and lower (B) decks. (Courtesy San Francisco History Center, San Francisco Public Library.)

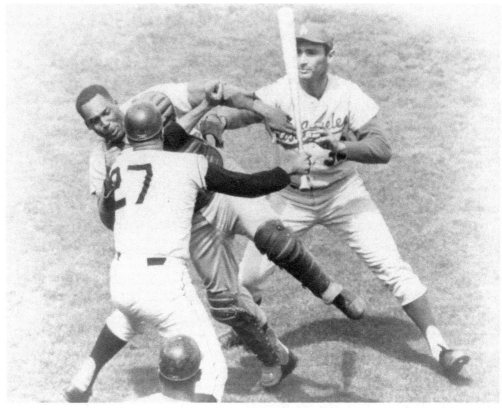

On August 22, 1965, Giants pitcher Juan Marichal (27) thought Dodgers catcher John Roseboro had thrown the ball too close to his ear when returning it to pitcher Sandy Koufax (right). A fight ensued when Marichal hit Roseboro three times in the head with his bat, causing a cut to Roseboro's head. The two men later became friends after retirement, and Marichal spoke at Roseboro's funeral in 2002. (Courtesy Rick Swig.)

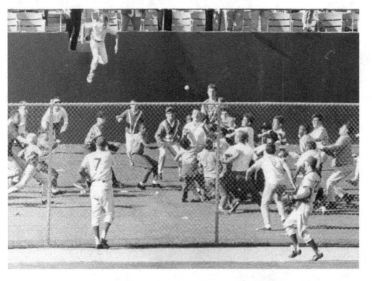

Fans rushed to catch Willie Mays's 499th career home run ball in the eighth inning of the second game of a double-header against the Chicago Cubs on September 12, 1965. The Giants won 9-2. (Courtesy Russ Moshier.)

THE FINEST BALLPARK IN AMERICA

Catcher Tom Haller spoke with Bob Bulawsky (left) and Joey Felice (second from left) of St. Monica's Parish in San Francisco at the Fifth Annual Catholic Youth Organization Giants Day held on August 24, 1966. Msgr. Peter Armstrong is seen standing behind the boys. Some 6,000 Catholic Youth Organization baseball players were on hand to watch as Haller presented trophies to the champion teams. (Courtesy Rick Swig.)

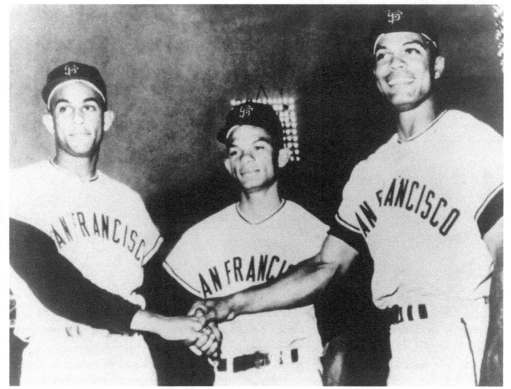

The Alou brothers, the only three brothers in history to play in the same outfield, played on September 22, 1965, in a game against the Cincinnati Reds; Jesus (left) played right field, Matty (center) played left field, and Filipe played center field. Two weeks earlier (pictured), against the Mets in New York, they were the only three brothers to ever bat consecutively in the same inning. Felipe returned to the Giants as manager in 2003. (Courtesy author's collection.)

RALPH J. GLEASON
2835 ASHBY AVENUE
BERKELEY 5, CALIFORNIA

Sun. Aug 14

Mate:

Oim so briddish this mawnin oi cant tulk yank.

Increasing rumors of leins on the box office, ticket scalping
as per the story etc

Ef i wuz you I would have your man go and LOOK at the
Candlestick park. They will be on a stand at 2nd base.
Nobody will be on the field. to get to second base they
will have to cross the open unguarded field. when it
was mentioned (by me) that this was the moment of truth
Tom D. said he didn't care what happened after they got
into the park!

So isuggsted the marines. no kidding. they wer going to
give seats to blind kids etc etc and i sad why not to
the marines, special seats ON the field and let the
Bs come thru the marines which ought to discourage the
teenie boppers from flying out of the bleachers on ththe
field and lynching the lads.

it will be hard enough to get them to the stage but to
get them back FROM the stage to the ax door 15 feet
behind the foul ball line is going to be murder. no
copter will take them unless they can con the marines
into it. the commercial lines turned them down. the lads
will have to walk towards 30,000 or 40,000 fans.

You must have faced this somewhere before. it seems to me
to be very dangerous. they are now hustling phone in prizes
with tickets becaus sales are off and they ran an advt
today (enclosed) which MEANS they are hurting. it's the first
newspaper ad donoghue and mitchell (tempo productions) have
ever run here.
my first col after vacatioj is the day they play here and i
will print full instructions on how to get into the dressin
room, how to get a red pass, time of arrival and departure
and place (why not theoak and airport)and other goodies
calculated to make this the final sf date.

can you believe the vatican newspaper? i must say i am disappointe d
that john came on so much like a cop out. --jesus WHO?

Ralph J. Gleason sent this letter to Bob Bonis, the Beatles' tour organizer, two weeks before their concert. Gleason was the pop and jazz critic for the *San Francisco Chronicle* and was a founder of *Rolling Stone* magazine. Tom D., to whom Gleason refers in the letter's third paragraph, was Tom "Big Daddy" Donoghue who, with his partner and fellow KYA disk jockey Bobby Mitchell, owned Tempo Productions, the concert promoter that was scheduled to advertise all concerts in 1965 at the Cow Palace. When the Beatles changed promoters, Tempo had to take legal action, but the settlement gave Tempo the right to promote the concert. The Beatles arrived at Candlestick Park in a bus directly from the airport and were followed by a Loomis armored car. Following four opening acts, including The Ronettes, the Beatles took the stage set up at second base. Their 11-song concert was over in 33 minutes. (Courtesy Jeff Hoganson.)

Capitol Records, Electrical and Music Industry's (EMI) American division, distributed this poster for the Beatles concert. This was the last of a 14-city U.S. tour and no one but the Beatles themselves knew this was to be their last public concert. On the plane after the concert, George Harrison reportedly said, "Well that's it. I'm not a Beatle anymore." EMI produced the Beatles until 1968 when the Beatles formed Apple Records. (Courtesy Len Hruszowy.)

As the Beatles performed their concert, there was an armored car parked behind the stage in case they needed to get away quickly. There was a fence around the stage to protect them from the crowd. Attendees reported a lot of screaming but no rush to the stage. The singers left the stadium in the armored car and were driven back to the airport. (Courtesy *San Francisco Chronicle*.)

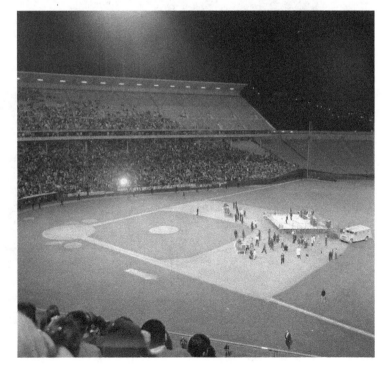

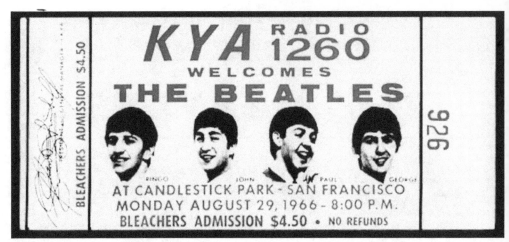

Only 25,000 tickets were sold in the 42,500-seat stadium for the Beatles concert at Candlestick Park on August 29, 1966. Priced from $4.50 to $6.50 per ticket, the Beatles received 65 percent of the gross, the city received 15 percent, and the promoter, Tempo Productions, suffered a financial loss. Popular Bay Area KYA disc jockey "Emperor" Gene Nelson was the master of ceremonies for the concert. (Courtesy Barry Hood Televideos.)

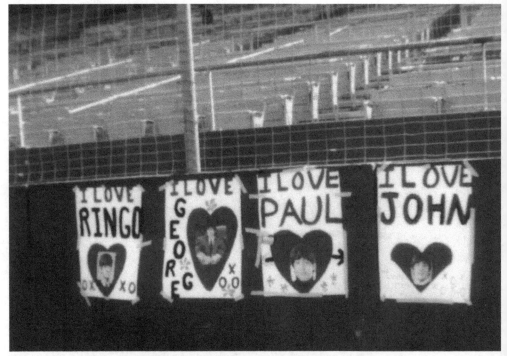

Fans who arrived at Candlestick Park early on August 29, 1966, were able to enter the stadium and put up posters along the wall in front of the seats. (Courtesy Barry Hood Televideos.)

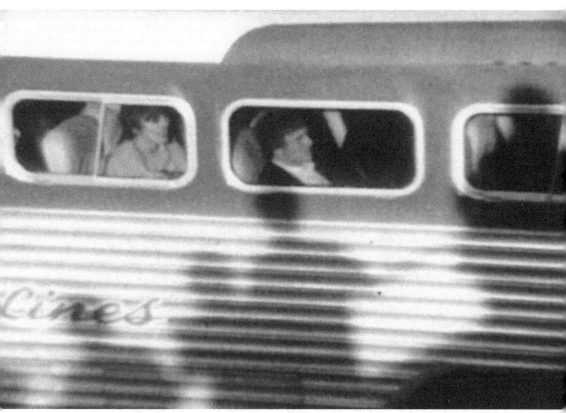

Fifteen-year-old Barry Hood of Eugene, Oregon, attended the Beatles concert with his mother. Hood had his 8mm movie camera and shot three 15-minute reels of film. Hood filmed as the bus carrying the Beatles from the airport arrived. Beatle George Harrison, left, and Neil Aspinall (special assistant to the Beatles) are visible in the bus windows. Seeing Hood with his camera, Harrison turned and took a photograph of him. In recent years, Hood has reviewed the footage and debunked a number of myths about this historic event. It is the only known footage of the concert and has been released as a video. (Courtesy Barry Hood Televideos.)

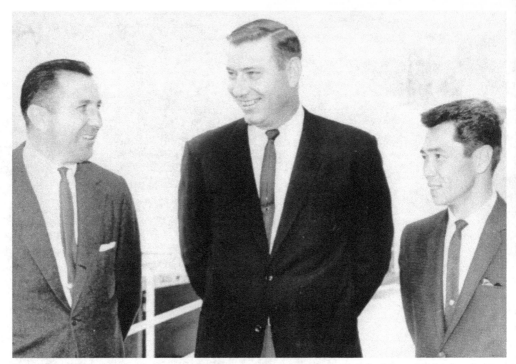

Joe Stanka (Nankai Hawks), center, and Charles Feeney (Giants), left, discussed the battle over pitcher Masanori Murakami while an interpreter looked on. Murakami was sent to Single A Fresno as an exchange student but was called up to the Giants on September 1, 1964, becoming the first Japanese player in the major leagues. He was allowed to stay with the Giants for the 1965 season before returning to Japan. (Courtesy Rick Swig.)

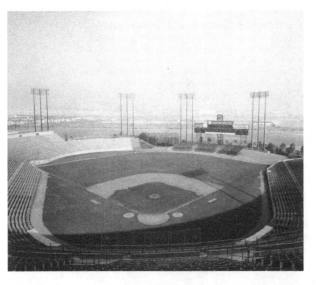

The original bond issue for Candlestick called for a multipurpose stadium, and John Bolles, the architect, planned it that way; however, the 49ers were not considered when the stadium was actually built. In 1969, mayor Joseph Alioto sent a letter to the board of supervisors suggesting a remodel of Candlestick. Pictured is Candlestick as it looked on January 29, 1969, before renovations had begun to make it a dual-purpose stadium. (Courtesy Mike Gay.)

THE FINEST BALLPARK IN AMERICA

3

IN THE DOLDRUMS

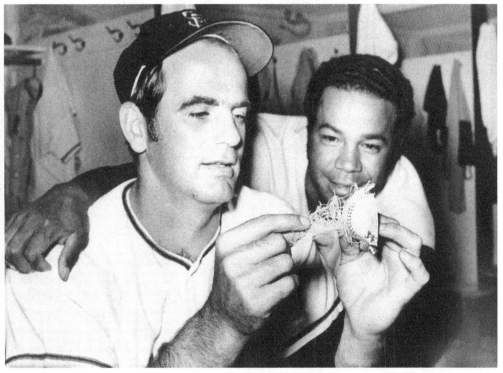

Hall of Fame pitchers Gaylord Perry (left) and Juan Marichal examined an older, more loosely wound baseball they loved. On July 2, 1963, at Candlestick Park, Marichal and Milwaukee Braves pitcher Warren Spahn faced each other for 15.5 scoreless innings until Willie Mays hit a home run in the bottom of the 16th inning. In 1962, manager Alvin Dark said, "They'll put a man on the moon before [Perry] hits a home run." On July 20, 1969, at 1:17 p.m. PDT, Neil Armstrong and Buzz Aldrin landed on the moon in Apollo 11. Thirty-four minutes later, Perry hit his first major-league home run in a game at Candlestick Park. (Courtesy Rick Swig.)

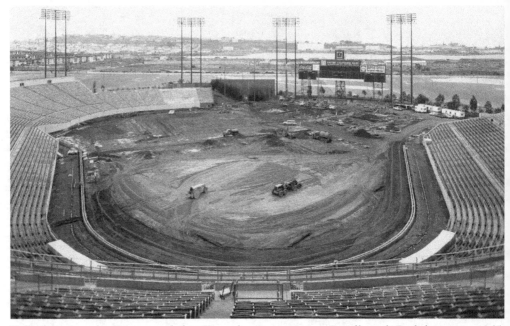

Talks between the Giants and the 49ers about converting Candlestick Park began in 1965. The 49ers, upset they had not been considered when Candlestick Park was originally built, were inspired by the Oakland-Alameda County Coliseum, under construction at the time. The coliseum was a dual-purpose stadium built for the Oakland Raiders and a possible American League expansion team. The Oakland Athletics had moved there from Kansas City in 1968. (Courtesy Mike Gay.)

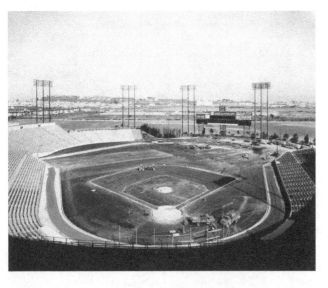

Phase one of the conversion of Candlestick Park began in 1969 with the construction of moveable right field stands. Four contractors were hired with the goal of completing the work in 18 months. The original estimate to complete the stands was $9.1 million, but this amount ended up jumping to $14 million with interest. The project, however, was completed without interrupting the Giants' schedule. (Courtesy Mike Gay.)

IN THE DOLDRUMS

Candlestick's nine-story scoreboard had to be moved from right field to left center field during the park's conversion. At a cost of $238,000 when installed in 1960, it was one of the first all-electronic scoreboards in history, and it required two men to operate its 900-button console and its 7,500 lamps. (Courtesy the Rupert family.)

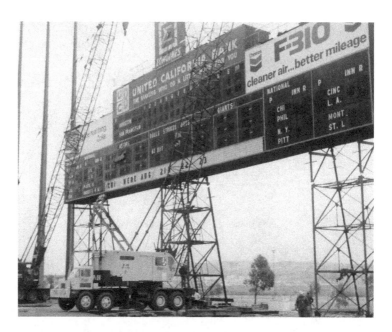

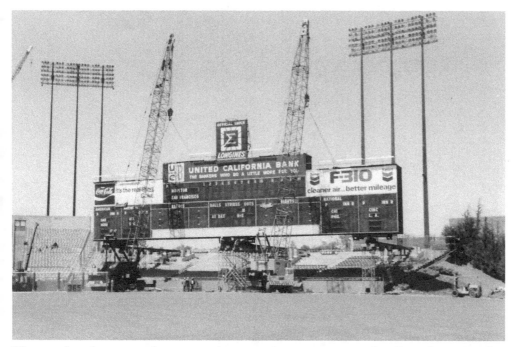

The scoreboard was moved to its new location where it remains today. Over the years it has undergone a number of modernizations up to and including all-digital video displays. (Courtesy the Rupert family.)

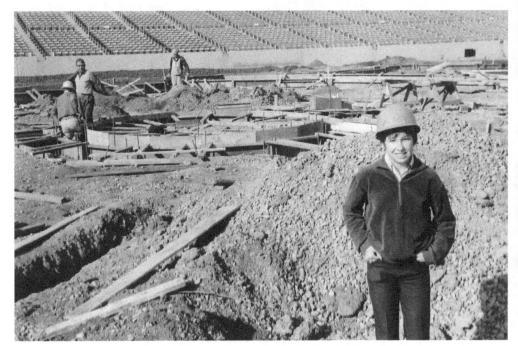

As part of the renovation, the field's natural grass was removed and replaced with synthetic Astroturf. The installation of the Astroturf required that a layer of asphalt be spread on the floor of the stadium. Horace Stoneham's granddaughter Kim Rupert is pictured. (Courtesy Rupert family.)

The left field buildings that housed restrooms and concession stands were demolished to make way for new double-deck stands. (Courtesy Rupert family.)

IN THE DOLDRUMS

Trenches were dug for roll-out stands that would provide seating on the east sideline for football but would remain stored during baseball games. John Bolles, the original architect of Candlestick Park, also designed the plan for the conversion. (Courtesy Mike Gay.)

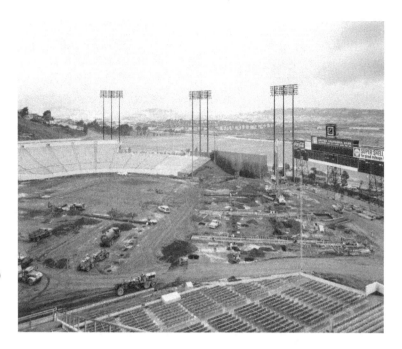

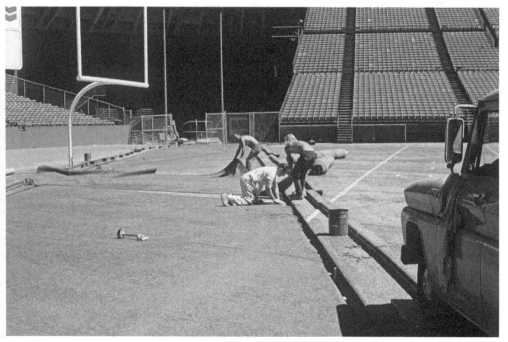

Installation of the Astroturf and the changes in the turf during its conversion from one sport to the other required the service of carpet layers. (Courtesy Mike Gay.)

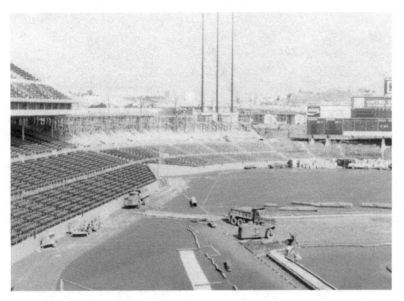

Preparations for the Astroturf field were nearly complete in this photograph. Construction continued during the 1970 baseball season but was planned so that it did not interfere with any Giants games. (Courtesy Rupert family.)

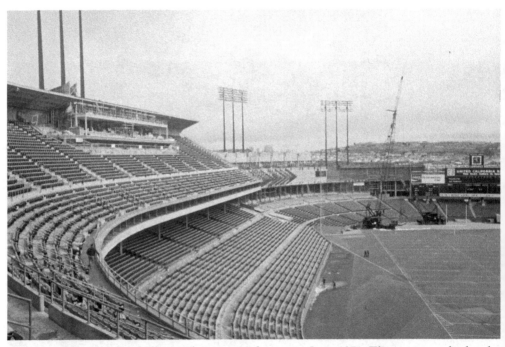

Construction of the football press box was underway in June 1971. This structure had to be built of aluminum because the stadium would not support a steel structure. Phase two of the modernization also included replacement of the wooden seats with red and orange plastic seats. Not visible in this photograph is the construction of Gate E, which was located outside of where the upper stands were being built. (Courtesy Mike Gay.)

IN THE DOLDRUMS

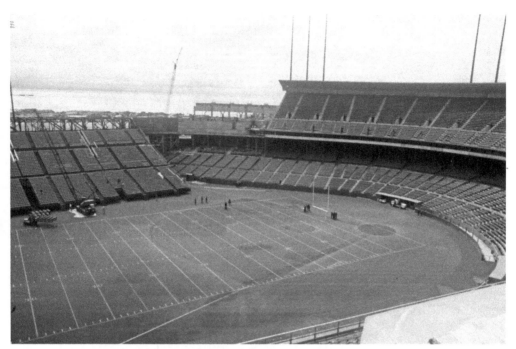

Construction of the upper deck along the right field line took place in June 1971 with the 49ers' first game at Candlestick Park just two months away. An additional light tower was added, and the old towers were strengthened for a total of 1,100 lights with triple the intensity of the old ones. (Courtesy Mike Gay.)

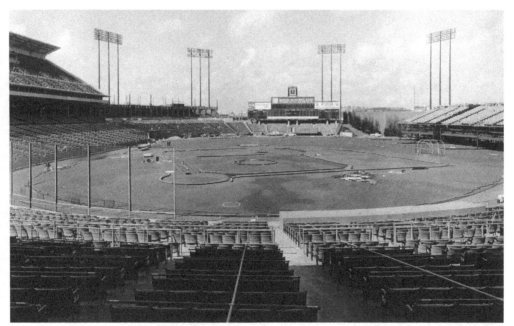

By 1970, the scoreboard had been moved and the moveable right field stands had been built. Construction then began on the left field stands. (Courtesy Jane Bolles Grimm.)

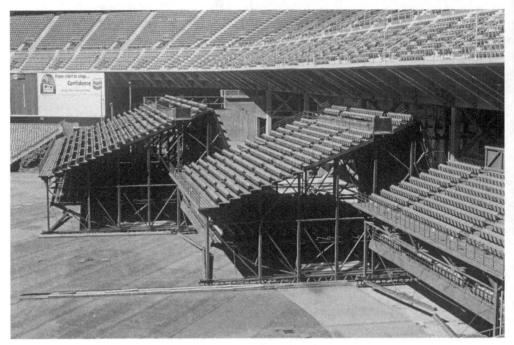

The roll-out stands on the east side of the field were designed by architect John Bolles to work like pullout bleachers in high school gymnasiums. The stands moved on rubber tires in tracks and had to be moved in a certain order. This design was copied for Shea Stadium in New York. (Courtesy Mike Gay.)

The last roof panel was placed in January 1972 and it finished the full enclosure of the stadium. It was hoped that the enclosure would reduce the wind, but it actually created negative air pressure in the bowl and caused the now-infamous swirling hot dog wrappers. (Courtesy Mike Gay.)

IN THE DOLDRUMS

A young fan is shown bundled up for a game against the Montreal Expos in August 1971. The Giants won the Western Division that year but lost to the Pittsburgh Pirates in the National League championship series. The remainder of the 1970s was not very good for the Giants, who posted four losing seasons and never finished above third place. Attendance was only 700,056 in 1977. (Courtesy Russ Moshier.)

Russian crewmen from freighters idled by a waterfront strike took in a game against the Montreal Expos on August 11, 1971. Vladimir Vinchel, a 21-year-old seaman on the *Suleyman Stalsky*, said of the game of baseball, "It is very slow—like a snail." (Courtesy Russ Moshier.)

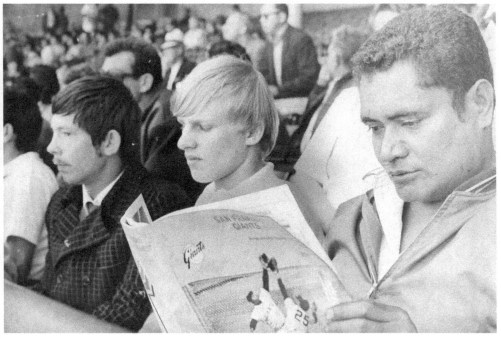

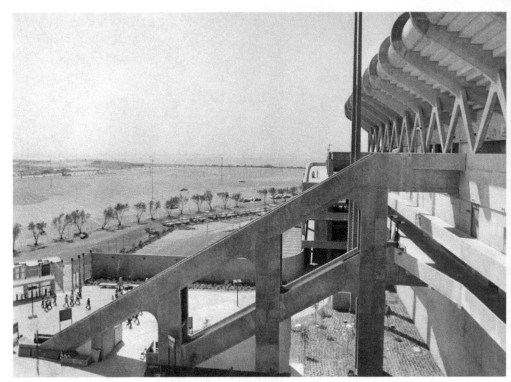

Gate F on the east side of the stadium was part of phase two's modernization. The upper escalator was the longest outdoor escalator in the world; a similar set of escalators was added at Gate A. The baseball press box and freight elevators were also installed. Those escalators and elevators were part of the original plan but had been cut for budgetary reasons. (Courtesy Jane Bolles Grimm.)

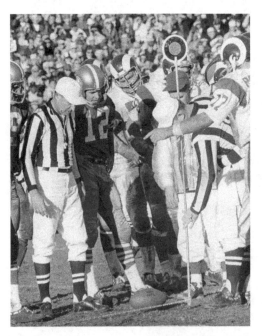

Quarterback John Brodie (12) of the 49ers watched a measurement in a game against the Los Angeles Rams during the 49ers' last season at Kezar Stadium. In their final game at the stadium, the 49ers lost 17-10 to the Dallas Cowboys in the National Football Conference championship game. Stanford graduate Brodie was one in a long line of great 49ers quarterbacks including Frankie Albert, Y. A. Tittle, Joe Montana, and Steve Young. (Courtesy San Francisco 49ers.)

IN THE DOLDRUMS

The 49ers played their first game at Candlestick Park in an exhibition game against the Cleveland Browns on August 8, 1971. Candlestick Park, with ample parking, seats rather than benches, and better restrooms and concessions, was a vast improvement over Kezar Stadium. (Courtesy Pat Ruffo.)

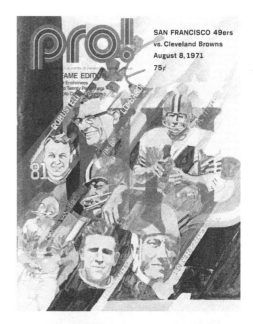

Players Leo Nomellini, left, and Joe "The Jet" Perry, standing, from the 49ers Hall of Fame, are shown talking with Josephine and Jane Morabito, the widows of the Morabito brothers. They were majority owners of the team after the deaths of their husbands but left the day-to-day operations to team president Lou Spadia. In 1977, the Morabitos sold their interest in the team to the DeBartolos. (Courtesy San Francisco 49ers.)

Dick Nolan coached the 49ers from 1968 to 1975 during which time they won the Western Division three times (1970–1972). The 49ers' losses in the Western Division playoffs were all at the hands of the Dallas Cowboys. After 1972, the Giants would not return to the playoffs until 1981 when they again faced the Cowboys and won. Nolan's son Mike coached the 49ers from 2005 to mid-season 2008. (Courtesy San Francisco 49ers.)

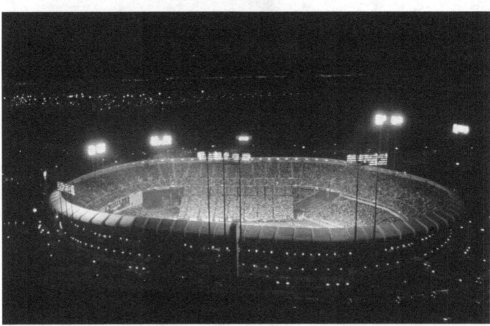

Candlestick Park was one of the best-lit stadiums for night games and it remains that way today with nine towers providing more than 350-foot candles of illumination. At the completion of the modernization, the stadium could seat 62,000 for football and 59,000 for baseball. (Courtesy Mike Gay.)

The 27-foot statue of Saint Francis of Assisi, positioned at the entrance to Candlestick Park, was commissioned by builder Charles Harney in the 1950s but was not erected until the 1970s. Local artist Ruth Cravath designed and created the concrete and Plexiglas statue of Saint Francis of Assisi, the Catholic saint for whom the city of San Francisco was named. (Courtesy author's collection.)

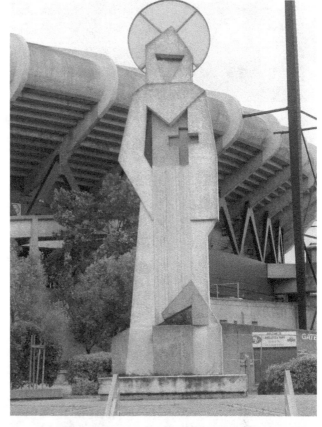

Amateur racing, time trials, and driving classes have utilized the large parking lots at Candlestick Park. As pictured, a Corvette club was active there during the 1970s. (Courtesy Mike Gay.)

Former 49ers wide receiver Gordy Soltau, closest to the camera, was the 49ers' radio color commentator on KSFO (560 AM) from 1973 to 1976. To his right is Lon Simmons, the 49ers play-by-play announcer from 1960 to 1980, also on KSFO. In addition, Simmons broadcasted for the Giants from 1958 to 1973. When he returned to them in 1976, he worked with Al Michaels. KSFO was the Giants' flagship station throughout these years. (Courtesy San Francisco 49ers.)

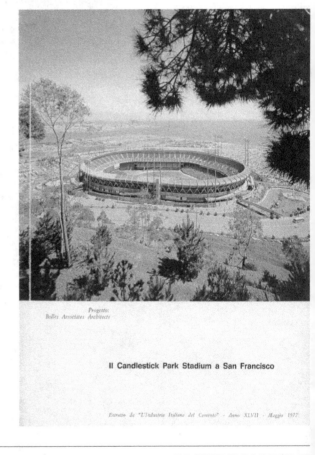

Progetto:
Bolles Associates Architects

Il Candlestick Park Stadium a San Francisco

Estratto da "L'Industria Italiana del Cemento" - Anno XLVII - Maggio 1977

Architect John Bolles used a photograph of the renovated stadium in a brochure prepared for the Italian construction industry. The brochure included extensive drawings of the stadium and highlighted its use of concrete. (Courtesy Jane Bolles Grimm.)

Head groundskeeper Matty Schwab is pictured setting home plate in September 1974. Schwab moved with the Giants from New York and was the third generation in his family to work as a groundskeeper. Horace Stoneham allowed Schwab to build an apartment at the Polo Grounds where he said Bobby Thompson's 1951 "Shot Heard 'Round the World" home run landed on his roof. (Courtesy Mike Gay.)

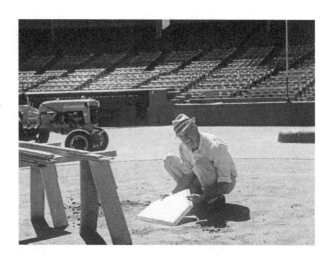

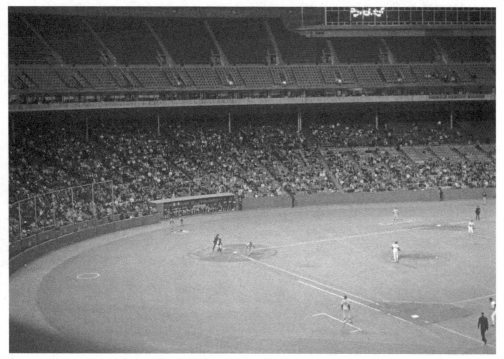

Even a game against the Los Angeles Dodgers could not draw a big crowd in 1974. The Giants struggled during much of this decade yet ended up producing two Rookies of the Year: Gary Matthews (1973) and John Montefusco (1975). (Courtesy Mike Gay.)

Second baseman Tito Fuentes (23) participated in a fan photograph day in 1974. Fuentes spent most of his career with the Giants and in 1981 became a radio announcer for the Giants on Spanish-language radio. (Courtesy Mike Gay.)

Mayor Dianne Feinstein and her husband, Richard Blum (center), visited with Giants executive Pat Gallagher. While in office, Mayor Feinstein funded a renovation of Candlestick Park that changed the promenade level boxes to suites and, most importantly, that included seismic strengthening, a move that paid off on October 17, 1989. (Courtesy Pat Gallagher.)

IN THE DOLDRUMS

Actor Ron Howard tipped his hat during a 1977 softball game between the KSFO All-Stars and the cast of the *Happy Days* television show. Directly to the right of Howard are Henry Winkler and Anson Williams (beside Winkler). (Courtesy Pat Gallagher.)

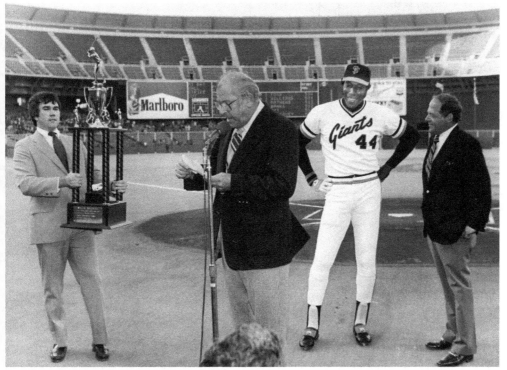

In 1978, Willie McCovey was honored for his 500th career home run. Pictured are, from left to right, Giants executive Pat Gallagher, announcer Joe Orengo, McCovey, and Bob Lurie, who bought the team in 1976. After years of declining attendance, partly due to competition with the Oakland Athletics, Horace Stoneham had agreed to sell the Giants to Labatt's Brewery; then Lurie intervened. Labatt's would have moved the team to Toronto. (Courtesy Pat Gallagher.)

The 49ers' mascot, Sourdough Sam, performs for the crowd. The caricature is based on the original 49ers logo, which was a prospector shooting two pistols and jumping in the air. (Courtesy Michael Olmstead e2k Events.)

On hand to participate in the Giants T-shirt Photograph Day was topless dancer Carol Doda, shown standing with Giants marketing executive Pat Gallagher. Doda performed at the Condor Club on Broadway Street in San Francisco, and in 1964 she became the first entertainer of note to dance topless. The topless trend soon spread to other clubs along the Broadway strip and then across the country. (Courtesy Pat Gallagher.)

IN THE DOLDRUMS

The 49ers drafted Heisman Trophy winner Steve Spurrier in the first round of the 1967 draft. He played for the 49ers for nine years, mostly playing backup to John Brodie, but only experienced moderate success overall. In 1976, Spurrier was traded to the Tampa Bay Buccaneers expansion team. (Courtesy Dennis Desprois.)

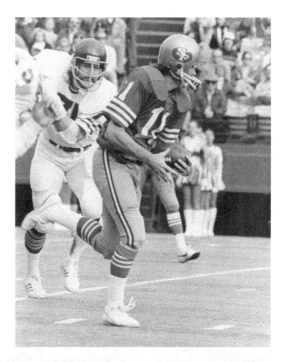

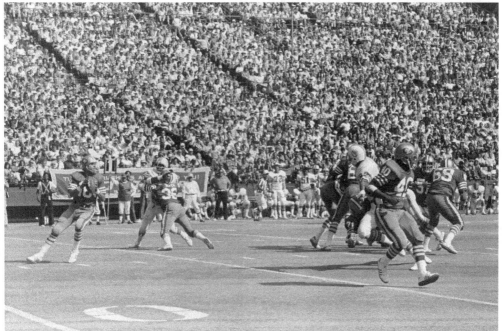

Quarterback Jim Plunkett, another local product, grew up in San Jose and won the Heisman Trophy at Stanford University. The 49ers got Plunkett in a trade with the New England Patriots in 1976. He led the 49ers to an 8-6 season in 1976, but after going 5-9 in 1977, he was released during the 1978 preseason. Plunkett joined the Raiders that year and led them to two Super Bowl victories. (Courtesy San Francisco 49ers.)

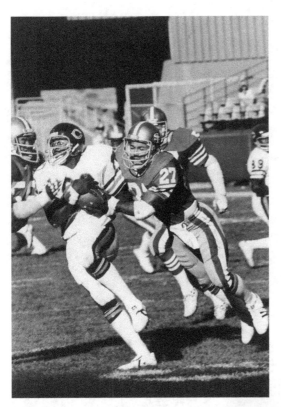

Free safety Tony Dungy (27) chased down a Chicago player on October 28, 1979. Dungy played just one season with the 49ers. Dungy had a successful career as the coach of the Tampa Bay Buccaneers and Indianapolis Colts. (Courtesy San Francisco 49ers.)

Pictured is Coach Bill Walsh being congratulated after his first victory as the 49ers' new head coach in a game against the Atlanta Falcons in 1979. That year, the 49ers went 2-14 for the second year in a row. In 1980, they went 6-10 before winning their first Super Bowl in the 1981 season. (Courtesy Dennis Desprois.)

THE CATCH AND THE EARTHQUAKE

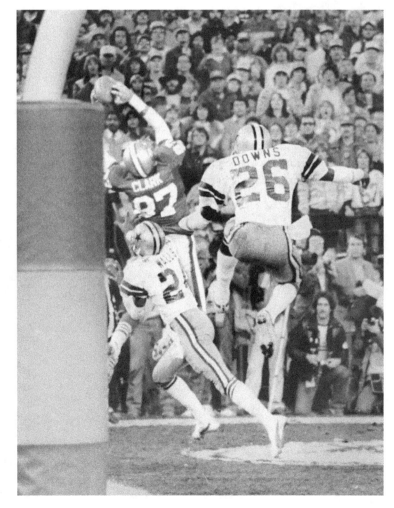

"The Catch" by Dwight Clark in the northeast corner of the north end zone of Candlestick Park on January 10, 1982, is considered one of the greatest plays in the history of the National Football League. With 51 seconds left in the National Football Conference championship game, it gave the 49ers a 28-27 lead; the 49ers defense held, sending them to the first of five Super Bowls they would win over the next 13 years. (Courtesy *San Francisco Chronicle*.)

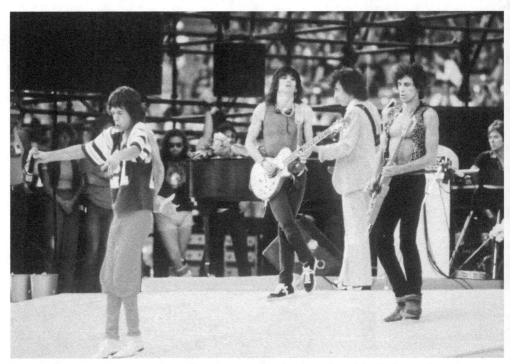

On October 17 and 18, 1981, the Rolling Stones played at Candlestick Park during their American tour. Also on the bill was the J. Geils Band. San Francisco rock impresario Bill Graham promoted the entire tour and because most of the concerts were during the daylight hours, designer Kazuhide Yamazaki was commissioned to design the elaborate and colorful facade. Of note, the Oakland-Alameda Coliseum was a much more popular concert venue due to the area's warmer weather; they also had a promotions department to bring in shows. (Courtesy Ken Friedman.)

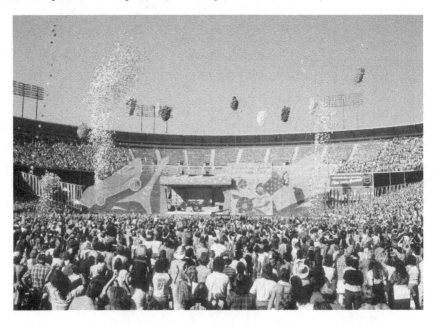

Radio broadcaster Don Klein was the play-by-play announcer for the 49ers from 1981 to 1984 for KCBS (740 AM). Klein was in the right place when Joe Montana threw the pass that Dwight Clark caught to beat the Dallas Cowboys in the 1981 National Football Conference game. Klein's description is often the audio heard when highlights of "The Catch" are broadcast. The 49ers' network was heard throughout California and Hawaii. (Courtesy Don Klein.)

OFFICIAL BATTING ORDER

CLUB **SAN FRANCISCO** DATE 9-4-81

ORIGINAL	CHANGE	ALSO ELIGIBLE
1 MORGAN 4	B / C	Blue / Ripley
2 CABELL 3	B / C	Alexander / Whitson
3 CLARK 9	B / C	Harqueshieu / Minton
4 EVANS 5	B / C	Lavelle / Holland
5 LEONARD 8	B / C	Breining / Trofts
6 HERNDON 7	B / C	Rowland / Martin
7 MAY 2	B BRENLY / C	Wohlford / Bennett
8 LeMASTER 6	B WHITSON / C SOTO Mi	Pettini / Sularz
9 GRIFFIN 1	B VENABLE / C HOLLAND	Bergman / Brenly
BERGMAN	D	Venable
MINTON	E	Ransom / Smith

MANAGER'S SIGNATURE

Frank Robinson signed this lineup card for a game against the Cubs. Hired by the Giants in 1981, Robinson was the first black manager in the National League. He stayed with the team until 1984. (Courtesy Rick Swig.)

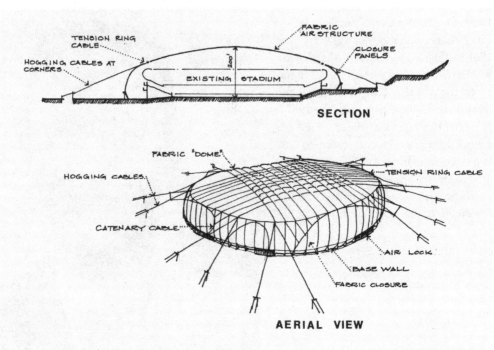

SECTION

AERIAL VIEW

SCHEME C

In January 1982, Mayor Dianne Feinstein formed a task force to deal with the wind problem at Candlestick Park. Giants owner Bob Lurie commissioned a study to look at adding a domed stadium; the study's recommendation was to build a fabric roof supported by air and cables. The cost, including other upgrades, would be $21.5 million. A new domed stadium in the South of Market area would be $90 million. (Courtesy Pat Gallagher.)

A report in the early 1980s described deterioration in the concrete at some key points in Candlestick Park. A five-year renovation plan was written and undertaken; seismic strengthening and repairs were done and other structural improvements were made. These changes, however, did not satisfy Giants owner Bob Lurie who said he would rather leave town than stay at Candlestick Park. (Courtesy Mike Gay.)

One of the original members of the 49ers' Gold Rush cheerleading squad, Sunnyvale native Teri Hatcher is shown performing in 1983. Hatcher was part of the Gold Rush for two years before leaving to start her career in Hollywood. She went on to star in *Lois and Clark* and *Desperate Housewives*. (Courtesy Michael Olmstead e2k Events.)

The Gold Rush first performed in 1983. Over the years, the squad has grown to its current 32 members. Members range in age from 18 to 28 years and average 15 years of dance and entertainment experience. Many of the Gold Rush members balance their 49ers involvement with full-time careers. Every year, the team's presence is requested at over 600 special appearances and charity functions. (Courtesy Michael Olmstead e2k Events.)

Second baseman Duane Kuiper (right) got a start on his future career as a broadcaster by interviewing teammate Don Buford in 1983. Kuiper began broadcasting Giants games in 1987 and later joined with former Giants pitcher Mike Krukow in the broadcast booth. Popularly known as "Kruk and Kuip," they continue as the lead television announcers for the Giants. (Courtesy Lon Lewis.)

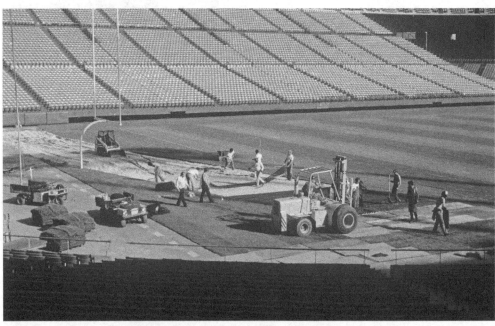

So that the Giants could play there in 1970, there were 110,000-square-feet of Astroturf installed before the renovations to Candlestick were completed. But during the renovation, cement dust and other material mixed into the turf and trucks were driven over it, making it one of the worst surfaces in the National Football League. The turf is now replaced yearly; pictured are groundskeepers laying matting and sod in October 1983. (Courtesy Mike Gay.)

The Giants used the weather conditions at Candlestick Park as a marketing idea themed, "Giants Hang in There." Fans who braved the elements and stayed for an extra-inning night game were given a Croix de Candlestick pin. The Latin *Veni Vidi Vixi* on the pin translates to "I Came I Saw I Survived." The Giants won awards for their marketing efforts from both the marketing industry and Major League Baseball. (Courtesy author's collection.)

Crazy Crab appeared in 1984 as a satire of mascots on other teams. Fans were encouraged to boo Crazy Crab, but some fans got carried away and threw things at him, therefore requiring Crazy Crab's costume to be reinforced. He only lasted the one season. In 1996, Lou Seal became the Giants' mascot. (Courtesy Lon Lewis.)

On July 16, 1984, the Giants hosted their second all-star game at Candlestick Park. To date, there have been 54 all-star games, and a pitcher struck out the entire side in only four of those games. But in 1984, Fernando Valenzuela, Dwight Gooden, and Bill Caudill all accomplished the feat, which guaranteed the National League's victory. (Courtesy Charlie Hallstrom.)

Ray Jason, shown with torches, juggled many different objects during his halftime and time-out performances. (Courtesy Michael Olmstead e2k Events.)

THE CATCH AND THE EARTHQUAKE

On January 20, 1985, coach Bill Walsh returned to Stanford Stadium for the 49ers second Super Bowl; the 49ers dominated the Miami Dolphins beating them 38–16. It was the only time in Super Bowl history that a team had won at home. San Francisco would be awarded two Super Bowls in the 1990s pending the completion of a new stadium. With no new stadium, however, the games were moved. (Courtesy Dennis Desprois.)

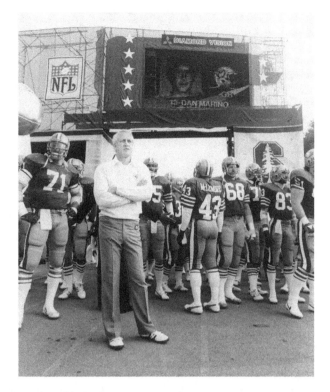

National Football League commissioner Pete Rozelle (left) stood with 49ers owner Eddie DeBartolo at Super Bowl XIX at Stanford. Rozelle, a graduate of the University of San Francisco and elected commissioner in 1960, oversaw the merger with the American Football League, the creation of the Super Bowl, the growth of television revenue, and football's growing national popularity over baseball. The man at the far right is NFL security manager Charlie Jackson. (Courtesy Dennis Desprois.)

Owner Eddie DeBartolo (first row, center), very popular with his staff as well as the players, posed with his staff after winning the Super Bowl in 1985. Staff members were often included in the celebrations after Super Bowl victories. (Courtesy San Francisco 49ers.)

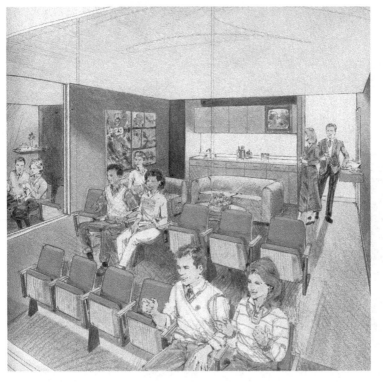

The "Suites of San Francisco" at Candlestick Park were completed in 1986; they featured upholstered theater seats, sofas, televisions, a sink, and sliding windows. Each suite-holder could order food and beverage from the caterer who only served the suites. (Courtesy San Francisco 49ers.)

The Royal Canadian Mounted Police Musical Ride made an appearance in a pre-game show in October 1985. (Courtesy Michael Olmstead e2k Events.)

The UCLA Bruin Marching Band performed during halftime at a 1985 game against the Chicago Bears. (Courtesy Michael Olmstead e2k Events.)

Quarterback Jeff Kemp (9) attempted a pass against the New Orleans Saints in 1986 while filling in for the injured Joe Montana. Kemp's father, Jack Kemp, was known for throwing the first touchdown pass ever thrown at Candlestick Park. Kemp senior had been the quarterback for the Los Angeles Chargers in the game against the Oakland Raiders. (Courtesy Dennis Desprois.)

Pictured is Harry M. Stevens beer vendor John Garvey during the summer 1986 Giants-Braves game at Candlestick Park in the lower box area. Vendor beer sales ended at Candlestick in 1987. Garvey recalls his lingo, "Beer here, hey ice cold bottle of Bud here." Garvey displayed the Budweiser bottle label forward, which vendors did to increase their sales volume. Stevens was a New York–based concessionaire, now defunct, that was founded by Harry M. Stevens. (Courtesy George Arriola.)

Hank Greenwald (left), play-by-play announcer for the Giants (1979–1986 and 1989–1996), is pictured interviewing Roger Craig, manager of the Giants from 1985 to 1992. After the last out of the National League championship series in 1989, Greenwald said, "Twenty-seven years of waiting have come to an end! The Giants have won the pennant!" His son Doug Greenwald currently announces for the Giants' AAA team, the Fresno Grizzlies. (Courtesy Hank Greenwald.)

Jerry Rice (80) is shown throwing a block for running back Roger Craig in a game against the Seattle Seahawks. Craig was the first running back to gain 1,000 yards rushing and 1,000 yards receiving in the same season. He played an important role in three of the 49ers Super Bowl victories. (Courtesy Dennis Desprois.)

Starting quarterback in 1980, Joe Montana quickly became one of the 49ers most popular players. He threw "The Pass" that led to "The Catch" that sent the 49ers to their first Super Bowl (XVI) win. Montana also led "The Drive" to win Super Bowl XXIII, the third of four that he would win. The *Sporting News* named him third on the list of football's 100 greatest players of all time. (Courtesy Michael Olmstead e2k Events.)

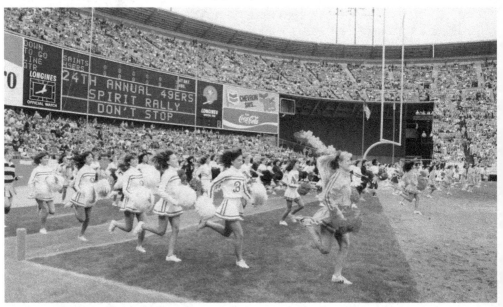

Many of the halftime shows over the years have featured local high school cheer squads. (Courtesy Michael Olmstead e2k Events.)

Bill Walsh built the 49ers into one of the best teams in American sports history. His West Coast Offense was copied throughout the National Football League, he worked to promote black coaches league-wide, and he left a long legacy of successful NFL coaches. After retiring, he returned to the 49ers as general manager. In 2007, he died of leukemia and a public memorial service was held at Candlestick Park. (Courtesy San Francisco 49ers.)

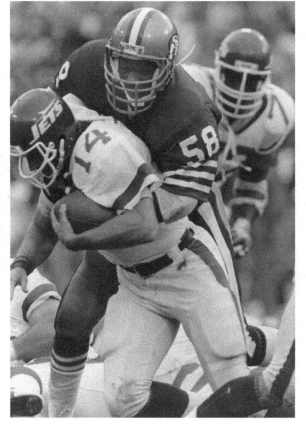

Linebacker Keena Turner (58) was part of the defense that helped establish the 49ers as the "Team of the Decade" in the 1980s. Drafted in 1980 out of Purdue University, Turner spent his entire 11-year career with the 49ers and participated in four of the team's Super Bowl victories. After retirement, he was involved in the television broadcast of pre-season games; he also became the 49ers' vice president of football affairs. (Courtesy Dennis Desprois.)

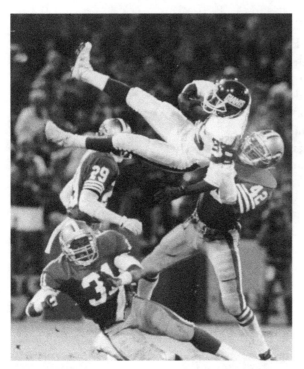

Ronnie Lott (42) makes one of his trademark hard hits on a New York Giants receiver. Drafted in the first round of the 1981 draft, Lott made an immediate impact and was the leader of the defense on four Super Bowl winning teams in the 1980s. Lott was elected to the Pro Football Hall of Fame in 2000. (Courtesy Bill Fox.)

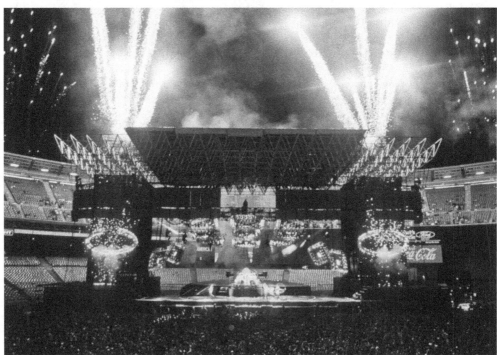

Fireworks and Van Halen ended the Monsters of Rock show on July 16, 1988. Also on the bill were the Scorpions, Dokken, Kingdom Come, and Metallica. A second show scheduled for the next day was cancelled. (Courtesy Ken Friedman.)

In a marketing idea devised by the National Football League in the 1980s, all of the teams had a Huddles mascot. Each team's mascot was dressed differently but shared the same name. A line of toys and other items were also produced. When the marketing plan failed, however, the 49ers brought back Sourdough Sam. (Courtesy Michael Olmstead e2k Events.)

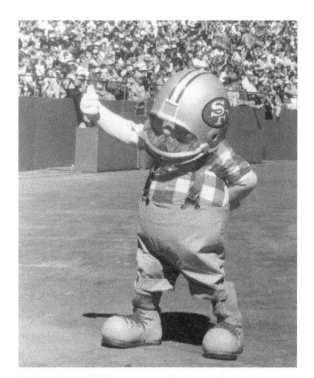

Bonnie Pointer of the Pointer Sisters and Michael Olmstead watched a halftime show from the sidelines. Olmstead's father, Robert Olmstead, began producing these shows for the 49ers in 1948. Those early days featured the 49ers Majorettes, the first female performing group in the National Football League to incorporate dance with props such as pompoms. Michael performed in his first halftime show at age five and produced his first show in 1971. (Courtesy Michael Olmstead e2k Events.)

LOWER RESERVED 26 21 1
Candlestick Park September 18, 1987

Visit of Pope John Paul II

San Francisco

1987

Candlestick Park September 18, 1987
LOWER RESERVED 26 21 1

There were 70,000 worshipers present when Pope John Paul II celebrated mass on September 18, 1997, as part of his 10-day tour of the United States. Famed jazz musician Dave Brubeck performed a special piece that had been commissioned for this event. (Courtesy Mike Gay.)

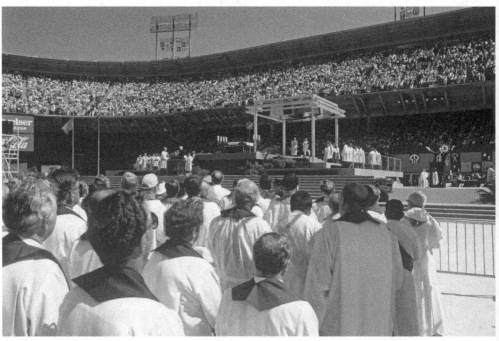

The Giants returned to the World Series in 1989 for the first time in 27 years when they faced the Oakland Athletics in the Bay Bridge Series. Previously the rival teams had played each other in 1905, 1911, and 1913, when they were in New York and Philadelphia. In 1989, the Athletics swept the Giants in four games. (Courtesy Andrew Holloway.)

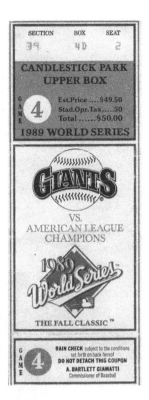

The 1989 World Series highlighted Bob Lurie's ownership of the Giants. Lurie had hired Al Rosen who, in addition to building the team by promoting players from the minors and making trades, won the division in 1987 and the pennant in 1989. Previously, with poor attendance and few winning seasons, referendums to build a new stadium had failed: in San Jose, Santa Clara, and twice in downtown San Francisco. (Courtesy Rick Swig.)

Connie *and* Bob Lurie

invite you to celebrate the

1989 World Series

Tuesday, October 17 - 3:30 - 5:00 p.m.

VIP Tent

Candlestick Park — Parking Lot C
Located directly behind centerfield, between Gates E and F.

Please present at door - Admits two - Not transferrable

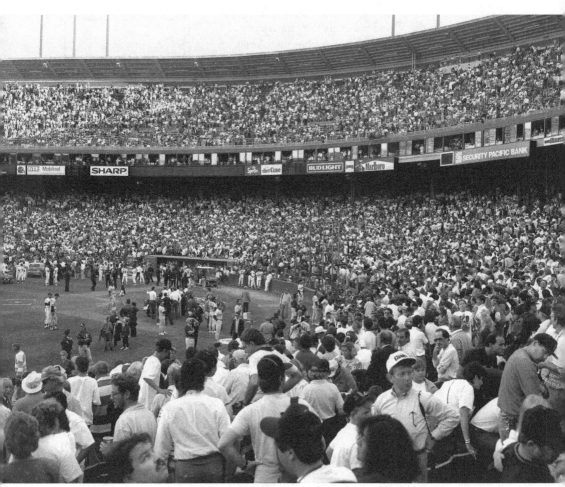

One minute after a 7.1-magnitude earthquake struck Candlestick Park at 5:04 p.m. on October 17, 1989, fans and players showed concern but remained calm. Police and players' families had come onto the field while other players looked into the stands for their families. The game was cancelled and police, using loudspeakers on a patrol car, directed fans to leave. As fans exited the stadium they could see smoke rising from fires in the Marina District on the north side of San Francisco. Electrical power was lost because the feed from the power company was lost, but there were no injuries, and the only damage to the stadium was some fallen concrete pieces from the roof and some cracking at expansion joints that were designed to move in an earthquake. Damage was minimized because of seismic work done a few years before and because of the original decision to build Candlestick on a rock foundation rather than on filled land. Even a small structural failure would have caused casualties and possibly a panic. Instead this was Candlestick Park's finest day. (Courtesy Dave Glass.)

Concrete was removed so the connections between the columns and the roof supports could be inspected after the 1989 earthquake. There had been little visual damage to Candlestick, but there was concern because of design similarities between the stadium and the Cypress Street Viaduct in Oakland that had collapsed during the earthquake. In a testament to the original design by John Bolles and the engineering consultants, no damage was found. (Courtesy Mike Gay.)

5:04 p.m.

Welcome back to the 1989 World Series

Before today's rescheduled Game 3 begins, Major League Baseball, the Giants, and the A's encourage everyone to join together in reflection of the events surrounding the earthquake which struck Northern California at 5:04 p.m. on Tuesday, October 17, 1989, minutes before Game 3 originally was to start.

The disaster took dozens of lives, injured thousands, left thousands homeless, and caused billions of dollars in damage. Its impact will be felt throughout Northern California for years to come.

At the same time, however, the earthquake mobilized an emergency army of dedicated public servants and private volunteers whose tireless relief efforts made heroes of ordinary citizens hour after hour.

We also salute and thank you, the 62,000 Candlestick Park fans, whose remarkable composure and restraint in the uncertain moments following the earthquake averted further chaos.

Tonight, we honor the resilience and indominatable spirit of our community to rise again. Let us all join together, not only in prayers for the loved ones lost, but in tribute to the survivors and selfless volunteers whose lives are changed forever.

We ask all our fans to take their seats before 5:04 p.m., when we will begin our pre-game schedule of activities.

After postponing game three of the 1989 World Series for 10 days, the series resumed at Candlestick Park on October 27, 1989. The capacity crowd of 62,038 received a handout (pictured) that included the lyrics to the song "San Francisco" on the back cover. The song had been made popular by the 1936 movie of the same name, a movie about the 1906 San Francisco earthquake and fire. (Courtesy Pat Gallagher.)

Damage to Candlestick from the 1989 Loma Prieta earthquake was the reason that the 49ers game against the New England Patriots on October 22 had to be moved to Stanford Stadium. The entire game-day operation, including the "Frisbee Dogs," had just four days to get organized. With the additional capacity of Stanford Stadium, extra tickets were available to the public, and all additional proceeds were donated to earthquake relief. (Courtesy Michael Olmstead e2k Events.)

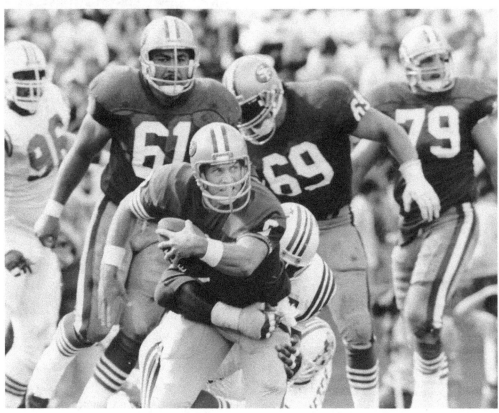

Quarterback Steve Young fought for more yardage in the game played at Stanford after the Loma Prieta earthquake. Young scored a perfect passer rating of 158.3 in that game when he completed 11 of 12 passes for 188 yards and three touchdowns in the 37-20 victory over the New England Patriots. Young became the team's undisputed starter in 1993 and led the 49ers to a Super Bowl victory in 1995. (Courtesy Bill Fox.)

5

A BITTERSWEET

FAREWELL

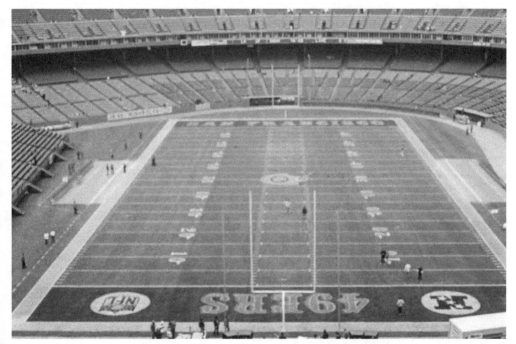

The field is pictured ready for another National Football Conference championship game. Candlestick Park has been the site for this game seven times, the most of any stadium in the NFC. Within the American Football Conference, only Three Rivers Stadium in Pittsburgh has hosted an equal number of championship games. (Courtesy Mike Gay.)

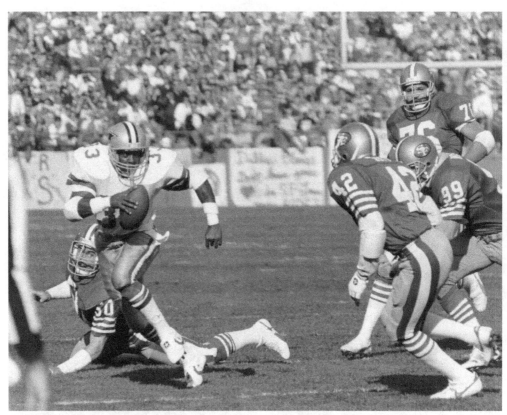

In a resumption of their great rivalry, the 49ers defense is pictured trying to stop Emmitt Smith of the Dallas Cowboys. The two teams faced each other in the National Football Conference championship game six times, including three years in a row, starting in the 1992–1993 season. Their wins combined, the 49ers and the Cowboys won six of the eight Super Bowls between 1989 and 1996. (Courtesy Dennis Desprois.)

George Seifert became the 49ers' head coach in 1989. In his first year, the team won Super Bowl XXIV, beating the Denver Broncos with a score of 55-10. Seifert won a second Super Bowl with the 49ers in 1995. He retired in 1996 but returned to the league in 1999 to coach the Carolina Panthers. Seifert attended San Francisco Polytechnic High School, located across the street from Kezar Stadium. (Courtesy San Francisco 49ers.)

A BITTERSWEET FAREWELL

Val Diamond, star of *Beach Blanket Babylon*, performed at a 49ers game. Begun by Steve Silver in 1974, *Beach Blanket Babylon* is the world's longest-running musical revue. (Courtesy Michael Olmstead e2k Events.)

Huey Lewis and the News performed the "Star Spangled Banner" before a 49ers game. The San Francisco–based rock group appeared frequently at Candlestick Park to perform the national anthem. (Courtesy Michael Olmstead e2k Events.)

Dave Dravecky (43) was a favorite among Giants fans for his courage after half the deltoid muscle in his throwing arm was removed because of a cancerous tumor. In his first game back at Candlestick Park in 1989 he defeated the Cincinnati Reds. Five days later, his humerus snapped on a pitch; two years later his arm had to be amputated. Dravecky has written two books about his battle with cancer. (Courtesy Pat Gallagher.)

In 1992, Peter Magowan put together an ownership group and purchased the Giants to prevent the team from moving to the Tampa Bay area. When asked what could be done to improve the stadium, fans suggested adding new left field bleachers to bring them closer to the fence, replacing the chain link fence with a new green fence, sounding a foghorn when the Giants hit a home run, and adding concessions. (Courtesy Mike Gay.)

Ideas for enclosing Candlestick Park continued in 1996 with this idea that called for cable and glass panels. The plan, however, did not mention the hundreds of seagulls that inhabit Candlestick Point. (Courtesy Mike Gay.)

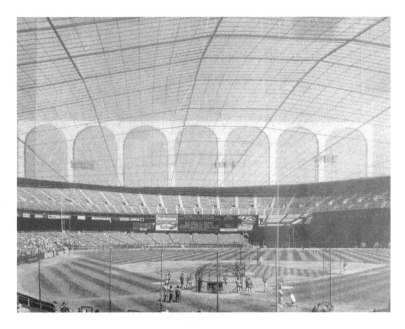

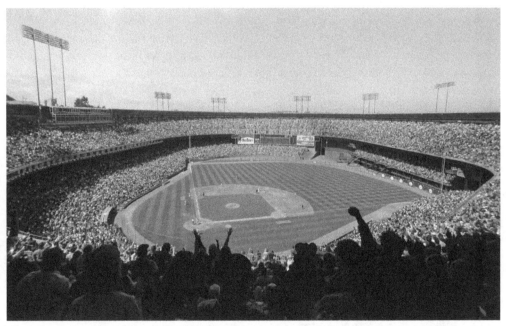

With 2.6 million fans in attendance, 1993 was Candlestick Park's best year. During the strike in 1994, attendance fell off and then continued to decline each year until 1997 when the Giants won the National League West. As Barry Bonds started to break records, though, attendance rose again, and the Giants began construction on their privately financed stadium at China Basin, an area once rejected but ready for renewal. (Courtesy Pat Gallagher.)

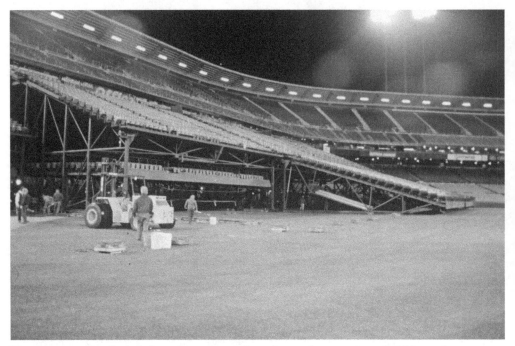

Transitioning Candlestick from one sport to the other took approximately 13 hours but was one of the fastest changeovers of the dual-purpose stadiums. Many stadiums required the use of cranes to lift sections of seats into place, whereas at Candlestick most of the moveable seats just rolled in and out. In the postwar-era, governments had begun getting into the business of owning stadiums in order to either keep teams from moving or to lure new teams. With the growing demands of professional football, and in order to control costs, dual-purpose stadiums were thought to be the answer. But in the late 1980s, baseball teams had opted for smaller old-style ballparks and football teams had opted for their own stadiums. (Courtesy Mike Gay.)

Volume services conducted a tasting to assess and improve the food at Candlestick. Among the tasters pictured is Giants executive vice president Larry Baer (center). He grew up going to games at the stadium so he knew both the difficulty of selling tickets and the pleasure of attending games. He said, "You can malign the stadium but you can't malign the memories." He became president of the Giants in 2008. (Courtesy Center Plate.)

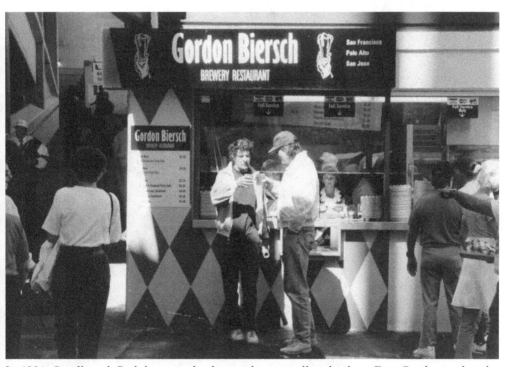

In 1994, Candlestick Park became the first stadium to sell garlic fries. Dan Gordon, cofounder of the Gordon-Biersch Brewery Restaurants, studied his craft at the Technical University in Munich, one day spending time in the garlic fields assisting professors with translations. Shortly thereafter, he added garlic to French fries to snack on during final exams. Gordon Biersch now sells the fries at over 40 concession locations throughout the country. (Courtesy Gordon Biersch Brewing Company.)

On April 5, 1993, Sherry Davis made history when she became the first female stadium announcer in Major League Baseball. Davis, who had experience doing voice-over work in commercials, won the job in open auditions. She remained with the Giants through their last game at Candlestick Park. (Courtesy Sherry Davis.)

The first Until There's A Cure Day was held at Candlestick Park in 1993. The Giants were the first team in sports to recognize the work of this nonprofit organization and their efforts to raise funds for and awareness of HIV/AIDS. Volunteers formed the ribbon pictured in center field, and AIDS quilts lined the base paths, each panel representing a victim of AIDS. The Giants continue their association with UTAC. (Courtesy Until There's a Cure.)

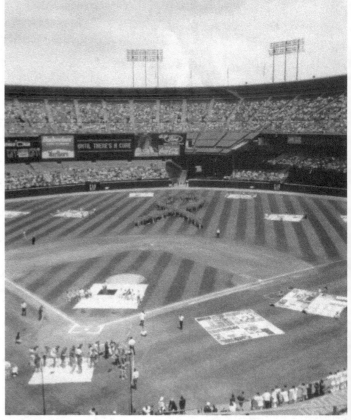

The floor of Candlestick Park was turned into a motocross track for the Mickey Thompson Stadium Off-Road Racing Series in November 1993. A variety of different vehicles, including motorcycles, small trucks, and buggies in the Super 1600 class, competed during this event. (Courtesy Dennis Mattish.)

SuperLites are shown racing on the flat dirt track at Candlestick Park. Originally these cars were modified Honda Odysseys. Among the drivers in this race was the defending class champion, 18-year-old Jimmie Johnson. Johnson is a four-time NASCAR Sprint Cup champion. (Courtesy Dennis Mattish.)

In 1995, in a naming rights deal worth $900,000, the name of Candlestick Park was changed to 3Com Park at Candlestick Point. In 2002, the name changed to San Francisco Stadium at Candlestick Point, and in 2004, it became Monster Park. It remained as Monster Park through 2008 and then reverted to Candlestick Park. Most fans, however, had never stopped calling it "The Stick." (Courtesy Mike Gay.)

A Chinese dragon, part of the Chinese New Year's parade held in San Francisco's Chinatown, performed during a halftime show at Candlestick Park. The first Chinese people to immigrate to the United States came to California in 1849 to participate in the Gold Rush. (Courtesy Michael Olmstead e2k Events.)

A BITTERSWEET FAREWELL

The Vince Lombardi Trophy was presented to the fans after the 49ers won their fifth Super Bowl in 1995, defeating the San Diego Chargers with the score of 49-26. Steve Young threw six touchdown passes that surpassed the record of five thrown by Joe Montana in Super Bowl XXIV. The 49ers were the first team in the National Football League to win five Super Bowls. (Courtesy Michael Olmstead e2k Events.)

A member of the U.S. Navy SEALS Leap Frogs parachuting team is shown landing in Candlestick Park. Even with controllable parachutes and the best training, members of this team had trouble with the unpredictable winds at Candlestick Point. Team members landed in the parking lot, in the adjoining neighborhood, and in the bay. (Courtesy Michael Olmstead e2k Events.)

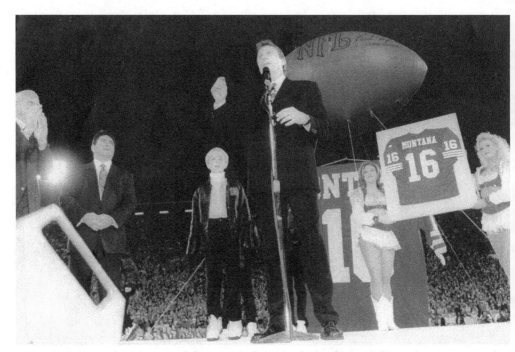

Joe Montana's number was retired during an ABC *Monday Night Football* broadcast on December 15, 1997. Montana had finished his career with the Kansas City Chiefs and had retired in 1994. He was elected to the Pro Football Hall of Fame in 2000 along with teammate Ronnie Lott and linebacker Dave Wilcox, who played for the 49ers from 1964 to 1974. (Courtesy Michael Olmstead e2k Events.)

Alumni players and members of the Gold Rush celebrated the 50th anniversary of the San Francisco 49ers in 1996. The 49ers have been an important part of the San Francisco Bay Area community, primarily through the San Francisco 49ers Foundation. (Courtesy Michael Olmstead e2k Events.)

Wide receiver Jerry Rice celebrated his 1,000th reception in 1996. He finished his career with 1,549 receptions, which was 447 more than the second-place record holder Marvin Harrison. Rice, considered the greatest wide receiver, is the all-time leader in every major statistical category for that position and is one of the greatest players in National Football League history. He was elected to the Hall of Fame in 2010. (Courtesy Michael Olmstead e2k Events.)

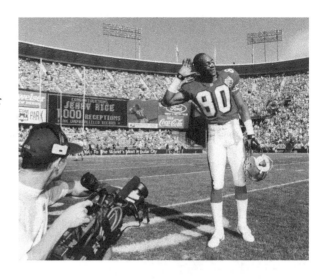

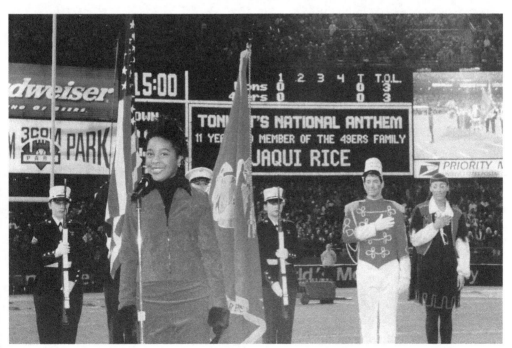

Stealing the spotlight from her father, Jerry Rice, 11-year-old Jaqui Rice performed the national anthem before a 49ers game. (Courtesy Michael Olmstead e2k Events.)

Owner Eddie Debartolo (left) honors wide receiver Dwight Clark (center). In 1981, Clark made "The Catch" to help beat the Dallas Cowboys in the NFC championship game and send the 49ers to their first Super Bowl. The emcee is San Francisco radio personality Bob Sarlotte, who serves as the 49ers stadium announcer. (Courtesy Michael Olmstead, e2k Events.)

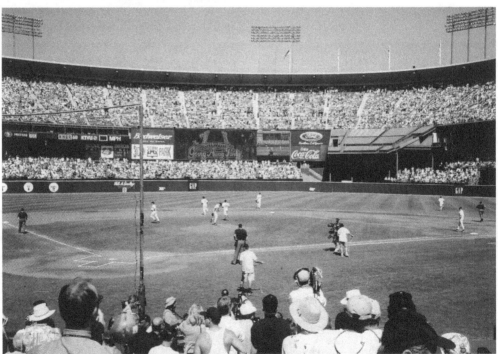

A sellout crowd watched the Giants take the field for the last time on September 30, 1999, in a game against the Los Angeles Dodgers. At the conclusion of the game, a helicopter lifted home plate and flew it across town to Pacific Bell Park. (Courtesy Mike Gay.)

6

MAKING THE BEST OF IT

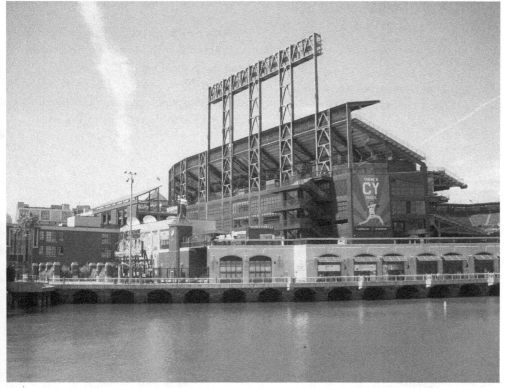

On April 11, 2000, one day short of exactly 40 years after their first game at Candlestick Park, the Giants faced the Los Angeles Dodgers at Pacific Bell Park. The $357 million stadium is located in the China Basin area of the San Francisco waterfront. It is the center of residential and business renewal in the South Beach and Mission Bay neighborhoods. At 41, 915 seats, it is about the same size as Candlestick Park when it opened. It became known as AT&T Park in 2005. (Courtesy author's collection.)

Marge Wallace, the Giants' number one fan, never missed a game and usually arrived six hours before game time. A chair engraved with her name sits outside the Giants Clubhouse at AT&T Park. Barry Bonds, having grown up around the clubhouse, was being introduced to fans in Union Square after a signing in 1993 when he recognized Wallace in the crowd, so he left the podium to give her a hug. (Courtesy Charlie Hallstrom.)

Marjorie Wallace

March 24, 1926 – June 21, 2003

"People ask me what I do in winter when there's no baseball. I'll tell you what I do. I stare out the window and wait for spring."

--Rogers Hornsby, Hall of Famer

Military personnel, policemen, and firefighters were honored at the 49ers' first home game after the September 11, 2001, terrorist attacks in New York City. Players as well as military personnel are shown holding the large American flag. (Courtesy Bill Fox.)

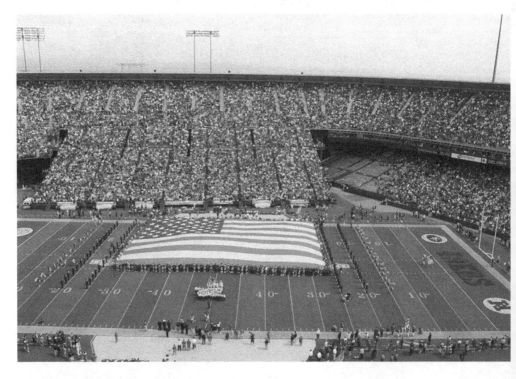

MAKING THE BEST OF IT

Quarterback Jeff Garcia, San Jose State graduate, signed with the 49ers in 1999 after winning the Grey Cup in the Canadian Football League. In their January 5, 2003, playoff game against the New York Giants, the 49ers were down 38-14 with 18 minutes left. Garcia brought them back to a 39-38 victory, but they lost in the next round to the eventual Super Bowl champions, the Tampa Bay Buccaneers. (Courtesy San Francisco 49ers.)

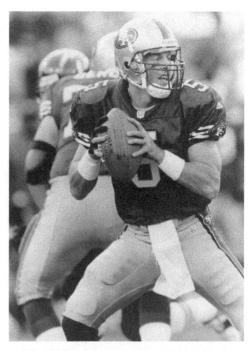

The 49ers locker room was enlarged in 2000 by taking the space previously used by the Giants. The original clubhouse in 1960 had wood parquet floors that did not hold up well to baseball spikes. Also, the wood swelled up and had to be removed after a water leak. (Courtesy Bob Mallamo.)

THE SAN FRANCISCO 49ERS SALUTE HIGH SCHOOL FOOTBALL

A display of helmets in the Gate F Plaza currently honors high schools in northern California. The 49ers, led by Jim Mercurio, vice president of stadium operations, have taken steps to improve the appearance and fan experience at the stadium. Faithful City, located in the parking lot before each game, is an interactive area for fans to enjoy. (Courtesy author's collection.)

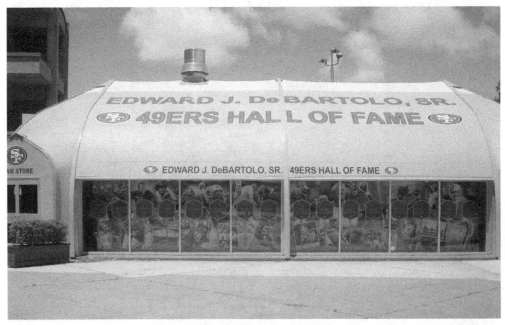

The Edward J. DeBartolo Sr. 49ers Hall of Fame is located in the Gate F Plaza. Its first inductee was Edward J. DeBartolo Jr. Other 49ers inductees who have their jersey numbers retired here include Steve Young (8), John Brodie (12), Joe Montana (16), Joe Perry (340), Hugh McElhenny (39), Ronnie Lott (42), Charlie Krueger (70), Leo Nomellini (73), Bob St. Clair (79), Jerry Rice (80), and Dwight Clark (87). (Courtesy author's collection.)

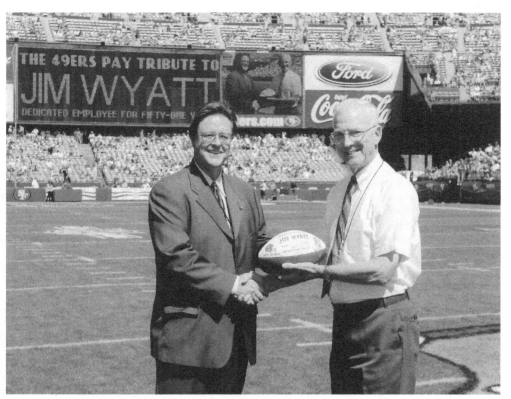

Team president John York (left) honored Jim Wyatt, director of guest services, for his 51 years of service to the 49ers. Wyatt began as an usher in 1952 and became the head usher shortly after the team's move to Candlestick Park; he worked for the team until 2009. York and his wife, Denise, took ownership of the team in 2000 as part of a financial settlement with her brother Edward DeBartolo Jr. (Courtesy Jim Wyatt.)

On June 8, 2010, voters in Santa Clara approved a measure that will allow city redevelopment funds to be used for the construction of a new stadium for the 49ers. The stadium, scheduled to be complete in 2014, will be located in the parking lot of the Great America theme park, across the street from the 49ers team headquarters. Candlestick Park is to be demolished after the 49ers move to their new home. (Courtesy author's collection.)

Visit us at
arcadiapublishing.com